GLOUCESTER MASSACHUSETTS

Digital Photography
for Graphic Designers

From Photo Shoot to Image Output

Lee Varis

ROCKPORT PUBLISHERS

D1534489

First published in the United States of America by
Rockport Publishers, Inc.
33 Commercial Street
Gloucester, Massachusetts 01930-5089
Telephone: (978) 282-9590
Facsimile: (978) 283-2742
www.rockpub.com

ISBN 1-56496-798-0
10 9 8 7 6 5 4 3 2 1
Design: Mary Ann Guillette
Cover Image: David Lemley Design
Printed in China.

Acknowledgments

When I was asked to write a book about digital photography for designers I originally thought, why for designers and not for photographers? After spending some months working on this book I thought, why not for designers?

This book would never have happened if not for a recommendation from Katrin Eisman, who encouraged me to write it. She also deserves credit for introducing me to Matt Wagner who helped with the contract stuff. The support from Rockport and especially my editor, Kristin Ellison, has been wonderful. I certainly need to acknowledge the support of my wife, Gila, and my kids Erika and Aaron—they put up with a lot of frazzled nerves and late nights. This book would not have been possible at all without the great contributions from the digital photographers represented in these pages. Finally, I'd like to dedicate this work to all of my fellow digital image makers who have been surfing the leading edge of the digital wave and have bloodied and callused themselves to survive into the new millennium. Keep pushing those pixels but remember to do something "analog" every once in a while.

—*Lee Varis*

Contents

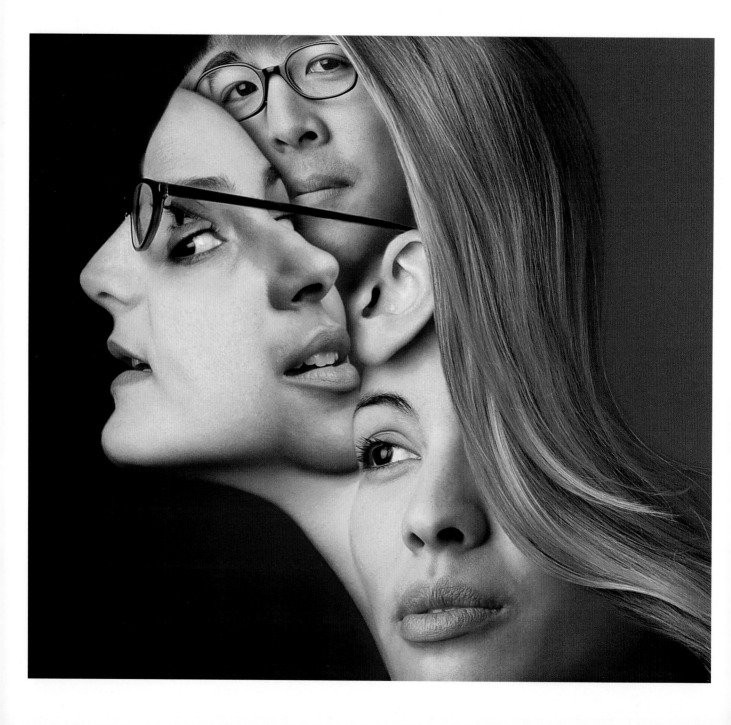

THE CHANGING FACE OF PHOTOGRAPHY

Designers and photographers are currently facing the most significant enhancement to creative collaboration since the advent of Polaroids. Digital imaging technology is radically transforming commercial photography in ways that will have a profound impact on the work that designers and photographers produce and the methods by which that work is done. Designers have generally been more familiar with computers than photographers but that is rapidly changing as more photographers embrace digital technology in their work. The computer brings the disciplines of photography, design, and print production into a fluid amalgam of visual communication; the borders have blurred considerably.

The photographer must now be part designer, part separator, and part printer as well as part web developer. It is the same for the designer who faces a greater challenge in integrating the many diverse elements of a project in ways that satisfy the increasingly time- and cost-sensitive client. Direct digital image capture offers a way to achieve image quality faster and, in the long run, cheaper than traditional film-based photography. We have seen digital-capture applied in a "photo factory" setting (catalog production, etc.) for at least the last five years. The resulting production benefits are widely acknowledged, but the new creative techniques that become available to designers on the photo shoot are perhaps the biggest incentive to adopt digital-capture.

Recently, the quality and resolution of digitally captured photography have made a big jump and the adoption of the technology by a new generation of creative artists has brought digital photography new respect as a creative tool. There is now a broader awareness of the benefits of digital-capture over traditional film-based photography, especially with businesses expanding into E-commerce and advertising on the Internet. Now, more than ever, it seems that you will "go digital or go home"!

This classic Bybee image was produced as a trade advertisement for Williams Communications illustrating the variety of people using the technology. All images were captured digitally with compositing and manipulation done in Live Picture and Photoshop. Ad Agency—Ackerman McQueen (Colorado); AD—Clay Turner Talent; Main face is Hollie Lemarr with Top Models/SF; Additional talent used—Jess Taclas with Boom Models/SF, Sonya Martinez and Cynthia Urquhart with Mitchell Talent/SF, Matthew Bentzel with Boom Models/SF.

What's In This Book

The designer utilizing digital photography has new ways of interfacing with photographers, streamlining workflow, and communicating with clients. These new methods bring new problems as well as new solutions. This book will identify the problems, propose solutions, and outline the best methods for working with the advantages of digital photography. While this is not a book about photography techniques, there is some discussion of the technical idiosyncrasies of digital capture and how it affects creative applications. The focus throughout will be on workflow. I explore some of the prepress issues that revolve around digital photography and provide recommendations for equipment and software that can enhance the designer's ability to evaluate, store, and transport digital photos. Digital photography involves the processing of bit map images so as a natural consequence there is considerable attention given to Adobe Photoshop and various ways to work with digital photography in this software. All of this information will help the designer evaluate the competence of a "digital" photographer and avoid miscommunications with experienced shooters. The importance of the Internet for the application of photography is obvious; the many ways that designers and photographers can use the Internet as a communication and transportation tool as well as a final destination for photography will be covered. Finally, several projects that illustrate some of the methods explored will be presented in some detail.

The technology of digital photography is changing rapidly and by the time this book is published several new camera systems will be introduced. I avoid, as much as possible, discussing specific equipment and concentrate on methods and approaches that can find applications with almost any combination of equipment. There is a section on different types of digital cameras and I do refer to specific models as repre-

sentative of these types—please be aware that some of these cameras may no longer be produced. However, a general discussion of the strengths of different types of digital cameras should help the designer evaluate the suitability of a particular photographer to a specific job.

Dominos © Lee Varis/Varis PhotoMedia

Assumptions and Conventions

I will make a few assumptions in this work:

01

Most serious designers are using Macintosh computers—if you use Windows computers you probably are experienced in troubleshooting your equipment and adapting your work to the "Mac-centric" output services in most of the urban centers of the United States. Because so much of the digital camera software runs exclusively on the Macintosh, all of the screen shots in this book are from the Macintosh; Windows users are expected to translate keyboard commands appropriately.

02

As a designer, you are interested in print and producing photography for print as the standard of quality. This book focuses on print production workflow with the assumption that if the photography is good enough for print, it should be good enough for use at reduced resolution for the World Wide Web.

03

This book assumes that the reader is familiar with standard design practices and printing terminology. A basic knowledge of Internet browsers and E-mail is also assumed.

The following conventions will be employed throughout this book:

Quick Tip: A condensed explanation of a particularly good method or especially useful information will be set off from the main text like this.

Tech Note: Technical information pertinent to the topic at hand will be displayed in a simplified format like this:

Typical line screens with suggested pixel resolutions:

175 lpi = min 240 ppi, max 350 ppi
150 lpi = min 180 ppi, max 300 ppi
133 lpi = min 150 ppi, max 266 ppi

Tech Talk: Longer sections about technical topics will be introduced like this:

Photoshop menu and keyboard commands will be illustrated with screenshots when appropriate, otherwise hierarchical menu command sequences will be stated in the text like this: File > Automate > Web Photo Gallery

01

Before diving into the intricacies of digital photography it is important to understand the overall workflow of a digitally captured project and how it differs from a traditional film-based workflow.

TRADITIONAL WORKFLOW:
The Shoot

A traditional photo shoot can start with a layout or design comp but often it can simply be a basic idea for the photography. A shoot is scheduled and the photographer, under the direction of the art director, captures images onto film. Whether in the studio or out in the field, Polaroids are usually used to judge composition and lighting. Sometimes, especially if the client is present at the shoot, the Polaroids are "signed off" by the client who signs his or her approval on the back. This is most often done for the benefit of the photographer to avoid arguments later on.

Processing

Once all the desired images are captured, the film is taken to a lab where it is processed. More often than not a "snip test" is conducted—a small piece from the lead or tail of a roll of film (or one sheet from several duplicate sheets of 4x5 (10x13 cm) or 8x10 (20x25 cm) film) is processed to check the exposure and adjustments are then made for the balance of the film. The film is processed and evaluated by the photographer who usually removes all the obvious misfires, outtakes, blinks and any obviously unacceptable shots. The remaining shots are then presented to the art director/designer and final choices are made and approved.

Digital-capture is particularly well adapted to imagery that will be manipulated in the computer. Designer and photographer can experiment with photos as they are taken and a creative feedback loop develops. Design and photography can be allowed to influence each other simultaneously.
© Lee Varis/Varis PhotoMedia

FPOs

In some cases layouts with photography are started using scans of the Polaroids as FPOs (for position only). Some design shops can scan FPOs or even finals from the film but usually the chosen shots are sent to a service bureau for scans. The service bureau scans the film—if the final size of the image in the layout has not yet been determined a low-res FPO may be produced for initial use.

Scanning

Once the final size is determined the film is scanned to size and a CMYK file is produced for use in separations. Big projects can require sophisticated OPI (Open Prepress Interface, a prepress standard file format since the mid-1980s) systems where low-res FPOs are automatically replaced in the RIP with hi-res files for output. This simplifies file management for the designer who then only needs to store low-res files locally.

Final Proof

During the design process comp prints may be made to aid in the visualization of the final outcome. Color adjustments may be made or specified based on these comp prints or "patch" color proofs (these are generally laminate-based proofs from test separations made at the time of the initial scans). Final proofs are generated from separations and any last minute adjustments are made before making the final film for press. The job can then be printed and delivered.

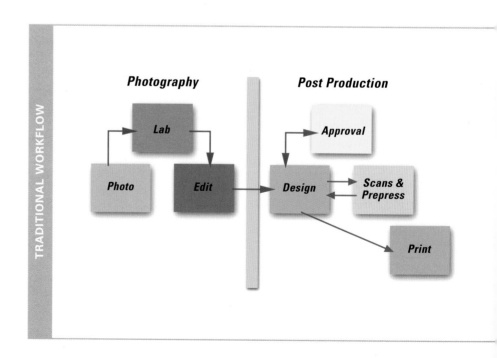

A lot of people are involved in this process and the images travel a fair amount between photographer and lab, photographer and designer, designer and service bureau, and designer and press. Decisions are made at each point and different people are involved with determining the final outcome. Responsibilities are clearly delineated between the separate stages in the process and there is a distinct separation between the photography phase and the post-production phase (represented by the gray bar in the illustration below) and often these are addressed with different budgets.

DIGITAL WORKFLOW: The Shoot
The digital photo workflow differs primarily in the number of stages and the amount of travel back and forth between stages. Design and photography are more tightly integrated and there is more creative synergy (symbolized here by placing design in the photography phase before the gray bar divider). The photography is initiated the same way, a shoot is scheduled, and images are captured. There is no need for Polaroids; shots are evaluated immediately as they are taken. Client, photographer, and designer can all view the photos at the same time, making evaluation and approval easier.

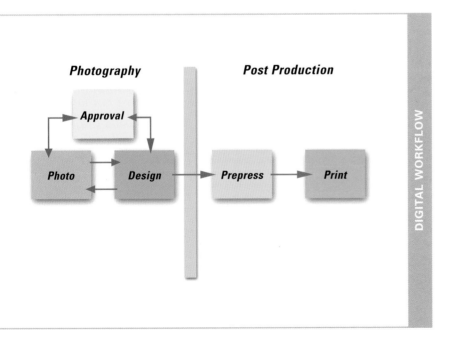

Photography Post Production

Approval

Photo Design Prepress Print

DIGITAL WORKFLOW

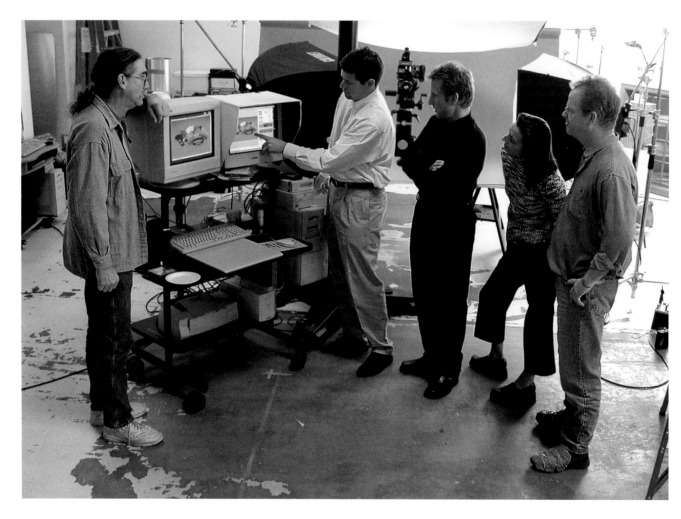

One big advantage of digital photography is that several people can evaluate a shot at the same time. This creates a better environment for collaboration at the shoot. © Lee Varis / Varis PhotoMedia

Output Ready Images

After the shots are taken they are "processed" on the spot—no need to send film to the lab or pull "snips." Shots can be edited and approved immediately or several images can be written to disk and sent back with the art director. There is no need to send out for scans as the "scans" are already done. Mostly, FPOs are unnecessary but they can be generated easily from the camera files if desired. Photography can be evaluated in the context of the design at the shoot and any adjustments can be made to optimize their integration.

Final Proof

The service bureau doesn't get involved until the separation stage and generally is simply outputting negatives and creating proofs from the files prepared by the designer. The job proceeds to the printer with fewer steps between photo shoot and final product. The photographer and designer have much more control over the final color but also must assume more responsibility for calibration with the service bureau and printer.

One can see that photography and prepress blend together and there is no scan stage. Problems can arise because responsibilities are not as clearly defined. Service bureaus cannot redo bad camera files that are generated outside of their control. This means that the photographer and designer have to assume the bulk of the role formerly played by the prepress worker. Since the final color is determined earlier in the process it is much more important that the photographer and the designer be calibrated with each other and the final output. (See monitor calibration in the next chapter.) Fortunately, these problems are not insurmountable and the benefits of shooting digitally far outweigh the drawbacks.

MIXED WORKFLOW

Real-world workflows can sometimes be a blend of these two approaches—one need not settle for an either/or solution. For instance, Smith/Walker Design of Seattle, Washington, is a graphic design firm with an in-house photo studio. Their clients include sporting goods/footwear, high-tech, and manufacturing companies. Jeff Smith describes their workflow this way:

"We begin the creative process at the comp stage. Developing roughs and final comps for client presentations. The art directors are encouraged to use a small point-and-shoot (Nikon 950) to get initial image ideas and for use in in-house roughs prior to our internal design meeting. On occasion, we shoot in studio for the comps only; these are preliminary shots to help develop the look and style of the finished piece for the presentation comps."

"On selection of a visual direction by the client, the AD produces the layout roughs that determine photo size, direction, and placement. These are reviewed by the photographer, working collaboratively with the AD to determine props needed and other logistics of the shoot. The art director is on hand at the shoot to approve all shots on the monitor."

Jeff Smith and Seth Campbell

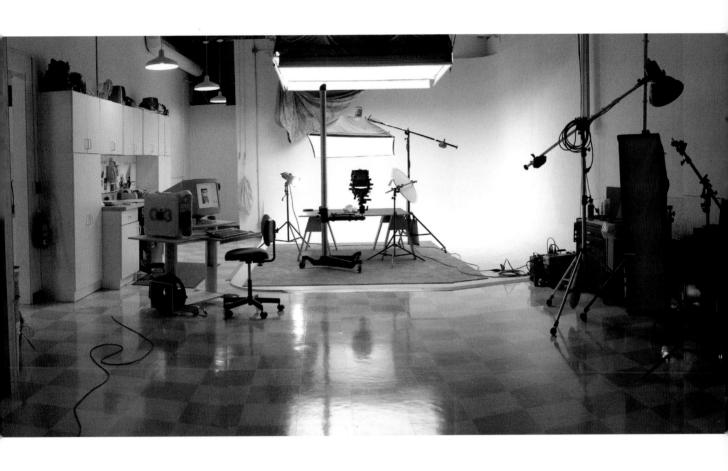

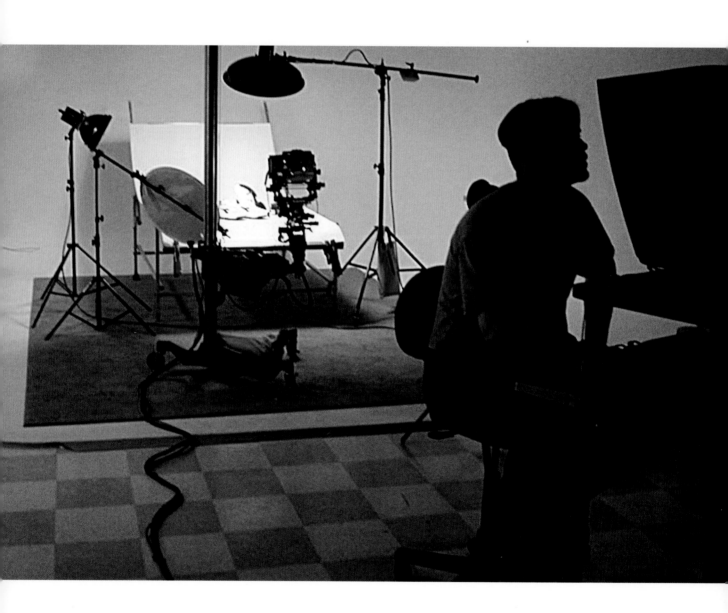

"After shooting, all final images are processed to an RGB file suitable for production use in the actual layout as an FPO image (for position only). These are typically down-sampled image files. The photographer then prepares all images from the shoot—processing out to appropriate tonal curves, setting neutrality, etc. *These image files are transferred to our prepress house for conversions and loose color proofing.*

*"The prepress house returns CMYK image files with proofs to our production staff. We then edit as necessary to outline, retouch, or alter the images to the requirements of the layout. They are then incorporated into the final files, proofed to the client, and finally returned to the prepress house for output of final film and contract proofing. ***

"All image files are archived on CD. The software we use allows us to archive the actual unprocessed (raw) capture data, which we burn to a separate CD from the processed image files. All are cataloged through Canto Cumulus (a popular asset management / image database application) so we can easily retrieve them as needed."

"We often use PDF files as proofs. We e-mail them to remote clients for all but the final approval. We require a signed copy of the final proof prior to releasing any files for film output.

"We rely on two different prepress houses for our work. When you are dealing with several million dollars worth of printing in a single year, the insurance policy that a prepress house represents is an important safeguard. We certainly could do our own CMYK conversions, but it is their extensive knowledge of the photomechanical reproduction of color that makes them invaluable. A signed contract proof solves a lot of potential problems in our business."

We can see in this example that the scanning step (* italicized text to the left) at the prepress house has been replaced by CMYK conversions and "loose color proofing"—not simply eliminated. This maintains the traditional responsibility of the prepress house for the final color and is a good way to go if you can always work with the same vendors (more on this later in chapter The Politics of Color). Also, the same people producing the final film produce the proofs, eliminating the need to have more expensive in-house proofing capabilities. The drawback is that there is more time spent transferring files back and forth to the prepress house and it is a little more difficult to calibrate to the proof.

Total Security

Another benefit of an all-digital workflow that you might need to consider is that of security. This became an issue for photographer Kim Simmons of Simmons Photography, a photo/design studio in Cincinnati, Ohio:

"When I was first told I would be doing the packaging photography for the *Star Wars* Episode 1 toy line, I knew I was going to have to deal with the security of the prototype toys and the security of the film at the lab. I had to put in a double alarm system in the studio to secure the assignment. The weak link was the lab! It was not something I wanted over our heads even though the toy company had cleared the two labs I have used for many years.

"So I requested that because of the possible security problems we shoot digital. After a few quick tests it was determined there would be no problems using digital files, although the separator had his doubts about using digital for all the packages."

Kim Simmons of Simmons Photography

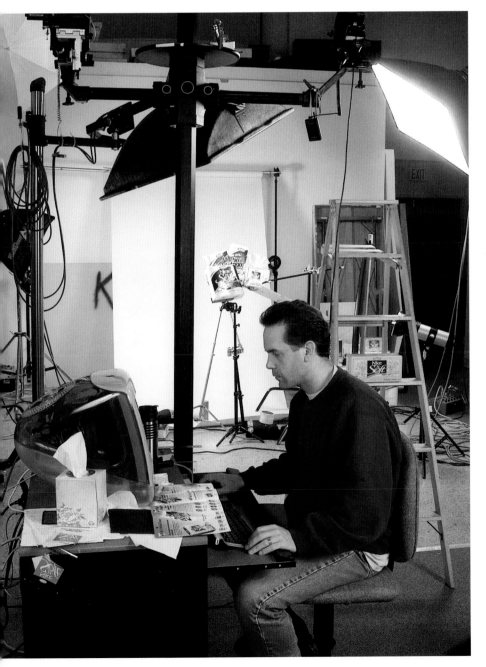

Dave Rafie of Simmons Photography at the computer. The ability to operate the camera from the computer can be a big advantage when the camera is high above the set. The art director may never have to get up on a ladder again.

Immediate Feedback Saves Time

The obvious differences between traditional and digital do not fully reveal the creative benefits to the digital photography workflow. A real, all-digital workflow allows for a non-linear collaborative approach to image making. Typically, designers become advocates after their first digital shoot and will insist on shooting digitally thereafter.

First, the speed of set-up is greater. It is much easier to get a fix on lighting and composition when designer, photographer, and client can, all together, view a test image on a 17-inch (43-centimeter) monitor a few seconds after it is shot rather than wait a minute and a half and then pass a 4-inch (10-centimeter) Polaroid around with a loupe. When the finished lighting is arrived at—you are done!

There is no need to shoot several more shots or bracket the exposures because you can tell right away if the shot is going to work. When shooting people, it is almost magical—every shot is displayed on screen as it is taken, you can tell when someone blinks or when everything is working well.

The author at his camera workstation.
© Lee Varis/Varis PhotoMedia

Creative Risk Taking

All of this immediate feedback encourages creative risk-taking because the pressure to save time and money by "playing it safe" is removed (many photographers claim that digital photography has improved their lighting skills). Images that are already digitized can be manipulated immediately and special effects can be experimented with during the shoot.

This has an effect on shots in progress and novel solutions to problematic images are encouraged in the process. My own feeling is that we're seeing just a fraction of the true creative potential of digital-capture that will be revealed in the years to come.

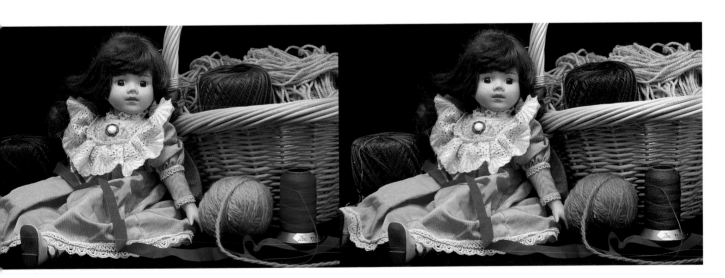

You can experiment with special effects like desaturating the background elements while you are shooting.
"Doll with yarn" © Lee Varis/Varis PhotoMedia

"Doll with yarn" normal w/o desaturation.

Quick Tip:

WEB PHOTO GALLERY

**Instant Image Approval
Via the Internet**

Digital-capture opens up the possibility of an Internet-based workflow where the remote viewing of image files as they are being taken can make collaboration and approvals over a distance possible. While art direction via remote may not be desirable, getting approval from a client who may be in another city while the shoot is going on can be a tremendous benefit. I have found Photoshop's new Web Photo Gallery command especially useful.

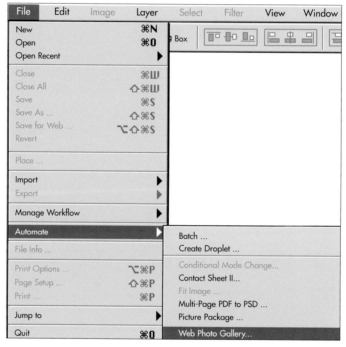

Adobe Photoshop Web Photo Gallery Menu

Web Photo Gallery Dialog Box

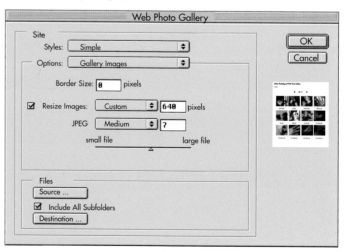

The Photoshop Web Photo Gallery automates the construction of a basic Web page with thumbnail links to screen res Images. Select a folder full of images, run the command and you end up with....

Web Photo Gallery Thumbnails

Web Photo Gallery Image

Web Photo Gallery Upload Folder

All the necessary image and HTML files are built and automatically placed in a folder of your choice...

Using Web Photo Gallery

To use the gallery pages you have to upload them to a Web site. Hopefully the photographer will have a Web site that can be used for these temporary pages. Once the gallery pages are created in a folder, that folder can then be uploaded via FTP software (Dartmouth College's freeware Fetch is a popular choice–get it at ftp://ftp.dartmouth.edu/pub/software/mac/) to the Web site. The folder name becomes part of a secret URL that the client can be directed to. It should look something like this: *mywebsite.com/clientfoldername/index.html*

Hi-res versions of the images can also be made available but it will require a little customization of the HTML for the gallery thumbnail page. Using something like Golive or PageMill, place links to binhexed archives of the hi-res images below the gallery thumbnails on the page and upload these archives to the same folder. The client or designer can then download the hi-res files simply by clicking on the links in her browser (without having to know anything about FTP software). This is all easier to do than it seems and it will be well worth your time to learn how to do it. It impresses the hell out of clients and it is much more reliable than sending files as E-mail attachments.

Tech Talk:

TYPES OF DIGITAL CAMERAS

It is helpful to know something about the different types of digital cameras, each having unique strengths and weaknesses. This information can aid the designer in evaluating the suitability of a photographer for a particular subject but be aware that all of these different types of cameras can take spectacular images; it is the expertise of the photographer, not the equipment that determines the quality of the images. Digital camera equipment falls into three broad categories: scanning backs, three shot, and single shot cameras. Some cameras manage to blend these differing approaches in an attempt to capitalize on the strengths of each.

SCANNING BACK:
Provides the Highest Resolution

The first type of digital camera is the scanning back. This generally takes the form of a slim rectangular box, slightly larger than a 4x5 (10x13 cm) film holder, which is inserted into the view camera back in place of the film. The camera is handled the same way it would be with traditional film, composing and focusing through the ground glass. Then, at the time of exposure a linear CCD (charged couple device—a type of silicon chip that converts photons of light into an electrical signal) element that spans the width of the back is moved across the image plane, capturing each row of pixels in red, green, and blue. When this "tri-linear array" finishes traveling the length of the image, a full color image is presented on the computer monitor. This process should be familiar to anyone who has used a flatbed scanner, as it is very much like a hi-res flatbed scanner attached to the back of a camera. Popular makes include: Betterlight, LightPhase, and Kigamo.

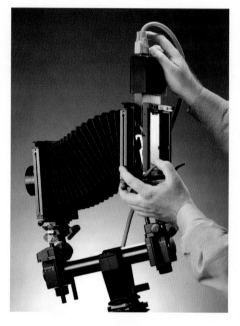

Betterlight Scannng Back with Sinar 4x5

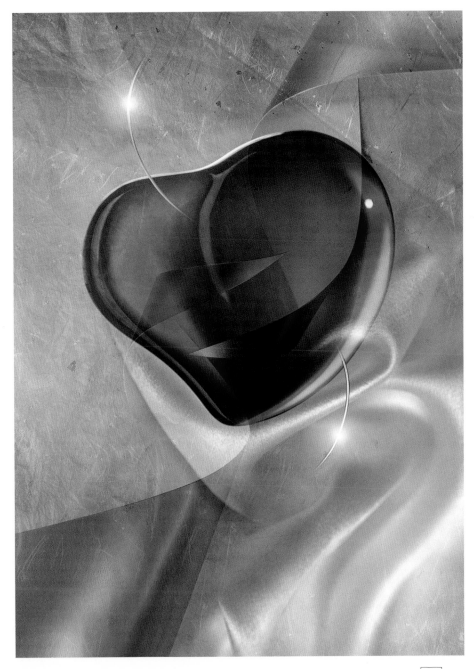

Done as a poster for the San Ramon Heart
Center, this image utilizes photographic elements
captured with a PhaseOne LightPhase camera and
blended together in Live Picture.
"San Ramon"© David Bishop

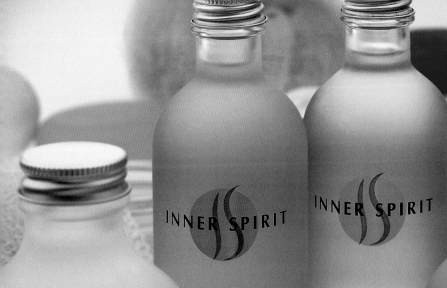

INNER SPIRIT

INNER SPIRIT

...ntic moments
...gent bath oil

...suous blend of
...ylang ylang & geranium

...7fl oz 200ml

ultimate stress redu...
indulgent bath...

a relaxing blend of
...avender, patchouli & pe...

6.7fl oz 200ml

INNER SPIRIT

INNER SPIRIT

inner serenity
...dulgent bath soak

a balancing blend of
...nium, lavender & cedarwood

10.1fl

morale booster
indulgent bath soak

a spirit-lifting blend of
orange, lemongrass & petitgrain

10.1fl oz 300ml

INNER SPIRIT

INNE...

SCANNING BACK: Pros and Cons

This approach is capable of the highest resolution of all the image capture devices, far exceeding the resolving power of film (and most lenses) and rendering incredible nuances of texture and tone. For this reason scanning back cameras are often preferred for fine art copy work, especially of large paintings, and many museums employ them in their cataloging efforts. The scan back camera can also be used in landscape and architectural photography as well as studio still life. The drawback to this approach is that because the CCD moves during the exposure, the subject must remain motionless—unless some special effect is desired! The use of electronic flash is also not possible and some sort of continuous light source must be employed. Large subjects require a high light level to achieve faster exposure times and this generally means lots of "hot" lights. The whole process is usually slower than shooting with the other two types of cameras. Product beauty shots that require slow careful finessing work quite well but catalog production with hundreds of shots can get tedious very quickly unless specialized lighting is employed.

Orbiculight set up for the Inner Spirit shot.

Special lighting equipment can make shooting with scanning back cameras much more efficient. Here the Orbiculight from Astron Systems allows the photographer to wrap the subject with a seamless light source. The close proximity of the fluorescent light provides for shorter exposure times and makes catalog photography with a scan back much faster.

The beautiful wrap around lighting in this scan back digital image was accomplished with the Orbiculight light table, a special fluorescent lighting system that is well adapted to the requirements of scanning backs.

Megavision T32 back with Sinar 4x5.

THREE SHOT:
Perfect for Studio Still Life

The second type of camera technology is known as a "three shot" or "three pass" camera. This typically takes the form of a camera back that can be attached to either a view camera or, more rarely, a roll film camera in place of the normal film holder or magazine. Three separate exposures are made through red, green, and blue filters to build a full color RGB file. These backs use an area array CCD where a rectangular chip covers a full image field, usually 2000 x 3000 pixels. Unlike the scan back, this area is somewhat smaller than the film format that would normally be used with the camera. Examples of this type include: Leaf DCB II, Leaf Volare, and Megavision T32.

THREE SHOT: Pros and Cons

This type of camera is well adapted to studio still life. The CCD array generates a live digital video preview on the monitor allowing the photographer to focus and compose on screen. This can be a real time saver when the camera is placed high on a tripod or camera stand, as there is no need to get up on a ladder to look through the camera. Set up and shooting goes quicker because the back stays on the camera and exposure is controlled through the software at the computer. It is also possible to automate the f-stop with a special electronically controlled iris in the lens.

Electronic flash (studio strobes) can be used because there is no movement of the CCD during the exposure. These cameras capture very high quality images easily usable for double-page spreads at 11x17 inches (28x43 cm) making them very popular for catalog photography. It is not possible to shoot moving subjects because three separate exposures are made and the subject must remain motionless to be in register in each of the three channels of the RGB file.

This image to the right was captured with a Megavision T32 three shot camera.
"Flowers" © Lee Varis / Varis PhotoMedia

SINGLE SHOT:
Versatility for People and Action Shots

The third type of camera is the single shot camera, which, as the name indicates, captures a full-color image on an area array chip in one shot. There is much more variety in this category ranging from medium format camera backs like the Phase One and Megavision S3 to 35mm style integrated body cameras like the Kodak DC series and the Canon D30 or Nikon D1.

In addition there are numerous rangefinder type cameras like the Nikon Coolpix 990 or Fuji Finepix at the lower end of the scale. These cameras employ a CCD or CMOS chip (Complementary Metal Oxide Silicon, an alternative type of imaging sensor) that has a "mosaic" pattern of red, green, and blue pixels on its surface. Processing software interpolates the differing luminance of each pixel into three channels of color.

Megavision S3 back with a Mamiya 645 camera.

Megavision S3 back showing the CCD.

The fast shooting capabilities of digital photography are a real asset in food photography. The colors in prepared foods change rapidly as the food is exposed to air. The instant previews in digital-capture can eliminate the need for multiple plates of "hero" food. "Chinese Beef" by Kim Simmons

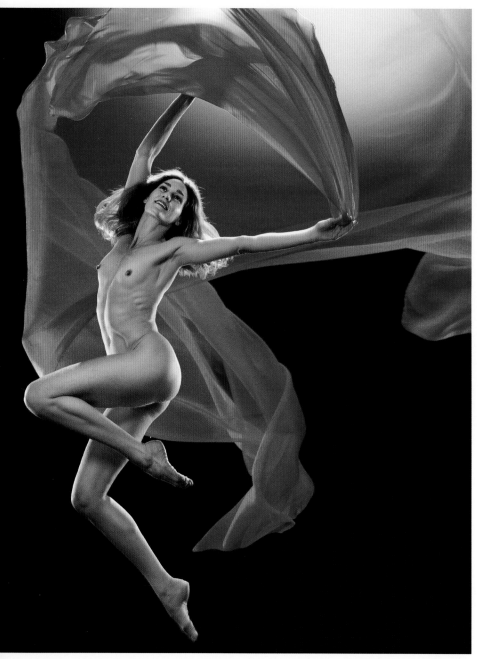

SINGLE SHOT: Pros and Cons

Moving subjects are no problem for the single shot camera, making this the choice for people, food, or any type of action photography. Generally, this type of digital camera can be treated like a regular film camera shooting under just about any kind of lighting. While the quality of the captures from these cameras is not quite the same as the three shot or scanning back cameras, the images they produce can be amazingly good, in many cases better, than film-based captures.

Single shot digital cameras make capturing movement easy. The dancer was able to see the shots immediately and make adjustments based on what was working as the shoot progressed. Additional blowing cloth was composited into the shot to complete the image.
Laurel Dance by © Lee Varis/Varis PhotoMedia

The biggest problem for these cameras is the occurrence of moiré when photographing certain fabrics. This happens when the frequency of the weave in the fabric interferes with the regular pattern of red, green, and blue pixels on the CCD. There are various hardware and software approaches that minimize this problem but sometimes only a partial solution is possible.

A particularly nasty example of a colored moiré in a single shot camera capture.

MULTI-MODE:
Ideal for Studio Still Life

A fourth type of camera has recently been introduced. Sometimes known as multi-mode or multi-shot cameras, these cameras employ a piezo motor to move a "mosaic" area array chip in single pixel increments in order to build up a "clean", non-interpolated full-color file in four shots.

This approach allows the camera to operate as a single shot or multi-shot camera. The Jenoptik eyelike, Jobo ProFile 6000, and Imacon 3020 are representative of this type.

Jobo Pro 6000 camera back on a Mamiya 645.

This is a standard pattern of alternating pixels used on most one shot digital cameras. The multi-mode cameras mount a CCD with this pattern on a moving element that offsets the position of this pattern in one-pixel increments. This diagram represents the start position.

Shot 2 is taken after the pattern moves one pixel to the right.

In shot 3, the pattern is moved one pixel down.

In shot 4, the final position in the four-shot sequence, the pattern is moved one pixel to the left. After four shots each pixel in the final image will have been exposed to red, green, and blue light for a complete three-channel RGB digital file.

MULTI-MODE: Pros and Cons

These cameras offer an additional mode they call "macro scanning" in which the piezo motor moves the CCD in sub-pixel increments building up a higher res capture in up to sixteen shots. The intention is to provide a system that combines the best of all possible approaches to digital-capture in one camera. In practice the system works well but is somewhat of a compromise being a bit slower and bulkier that a simpler single shot, a little more sensitive to vibration than a three shot, and having a much smaller imaging area than a true scanning back camera.

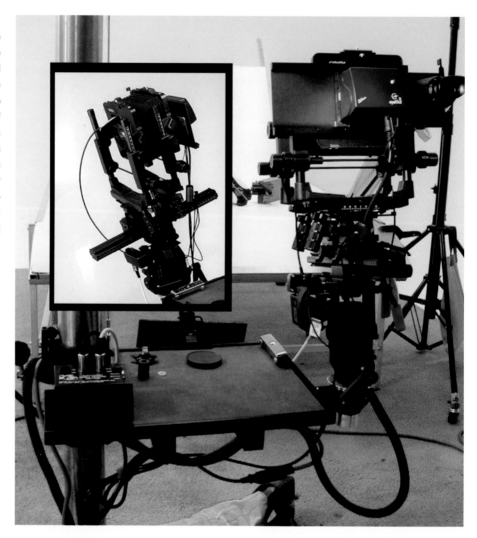

The Jenoptic eyelike single/multi-shot camera is seen here mounted on a viewcamera with a sliding back adapter. This allows the photographer to focus and compose on the ground glass in a normal manner and then slide the camera back into position for the final exposure.

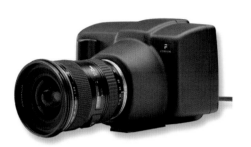

A new camera from Foveon, unreleased as of the writing of this book, looks promising. The camera features a new CMOS chip with 4k x 4k resolution and will capture full-color in one shot.

FOVEON: A New Approach

Finally, there is the unique system developed by Foveon. The Foveon camera uses a three-chip design, somewhat similar to three-chip video cameras, in which a prism splits the image, delivering it to red, green, and blue chips at the facets of the prism. Thus, the camera captures full-color, non-interpolated data in one shot. Previously, the implementation of this approach was considered too expensive because of the cost of CCD manufacture but Foveon has developed an inexpensive CMOS chip that performs almost as well as current CCD designs.

FOVEON: Pros and Cons

Although CMOS chips have lower signal-to-noise ratios (they exhibit more noise or apparent graininess at a given light level) than CCDs, the three-chip design makes up for most shortcomings and virtually eliminates the problems of color aliasing and moiré that occur with other single shot designs. The biggest problem for the acceptance of the Foveon system is the unusual form factor of the camera, which is basically a notebook computer with a lens attached.

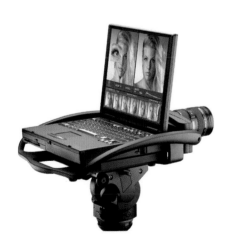

Scan Back

Three Shot

Single Shot

Multi-Mode

CAMERA TYPE
Scan Back
Three Shot
Single Shot
Multi-Mode

STRENGTH	WEAKNESS
High quality and highest resolution; ideal for landscape, architectural, and fine art copy	Can't capture movement Requires continuous light source
High quality and flexibility with light sources; ideal for studio still life	Can't capture movement in full-color
Captures movement; ideal for people photography	Color artifacts and moiré with certain fabrics
Versatile; ideal for studio still life and moving subjects	Clumsier than other designs when compared to their strengths and prone to image problems due to vibration

Even a quick sketch of the layout before the shoot can help eliminate resolution issues down the road.

02

PLANNING AHEAD FOR FINAL OUTPUT

There are a few things to consider when planning the digital photo shoot. As is normal for any photography with a specific use in mind, there should be some kind of a layout. This could be as simple as a box of a certain size in which the photo is placed or as complex as a detailed sketch showing the exact location of various elements in the shot. It is especially helpful to know the exact size of the final use because this often has an effect on the strategies for digital-capture—especially if the image is going to be used at a large size.

The most common mistake that designers make is assuming they can determine the final size later. This is an easy habit to get into when you deal with film-based captures—simply scan a low-res FPO and re-scan when you know what size you need. When you are, in essence, scanning at the time of capture, you need to at least have a good idea of the final size so you can maximize the quality of the image. If your final use is going to be smaller than 8.5 x 11 inches (22 x 28 centimeters) you can pretty much relax about the size of most image captures at the shoot.

However, you should not necessarily plan on cropping into an image and using a section at a larger size if you don't know how big you'll need to enlarge it. The resolution of digital camera files is important enough that we should explore this issue in greater depth.

When someone talks about the resolution of a digital image they are generally referring to the density of pixel information per inch (2.54 centimeters) at a particular image size. This is most frequently expressed as the number of pixels per inch (ppi) or dots per inch (dpi), i.e., 72 dpi. You almost never see 72 ppi even though pixels per inch is not exactly the same as dots per inch (more on this later). The size at which an image is displayed is critical to our understanding of resolution and it is often misunderstood. To say that an image is 150 dpi is meaningless without knowing the dimensions in inches of the image, the "i" part of dpi.

Grain vs. Pixel

Photographers often equate resolution with the "graininess" of an image and a low-res image is thought to be grainy. Resolution is also equated with focus and low-res images are thought of as soft or blurry. Grain and focus are issues that are completely separate from resolution in digital images.

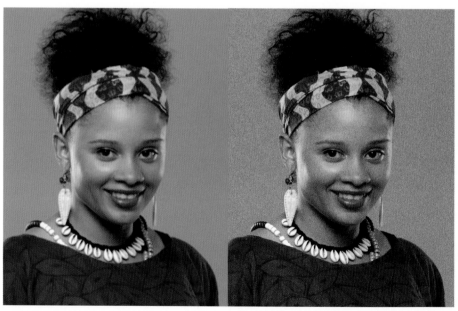

Pixilated image

Film grain affects the image in a different manner than low-res pixilation. Notice how you do not see "pixels" in the smooth background.

Pixel Size

Pixels are generally thought of as being very small. However pixels can be represented at any size; pixels themselves have no dimension at all. A pixel is a numeric expression of a square field of color. The pixels in an image fit together without seams to form an ordered grid. The red square below could be a representation of one pixel, 100, or 1000 pixels that have the same red value.

By randomly altering the values of every other pixel by 20 percent we can see that, in fact, we have a grid of 10 x 10 pixels in a two-inch square (254 mm square) and this image would have a resolution of five pixels per inch.

We can say that this image looks pixilated because we can see every individual pixel in this image. If you were to look at this image from ten feet (three meters), could you see the pixels? How about at twenty feet (six meters)?

This square could represent one pixel, 100, or 1000 pixels that have the same red value.

By randomly altering the values of every other pixel we can see that we have a grid of 10 x 10 pixels.

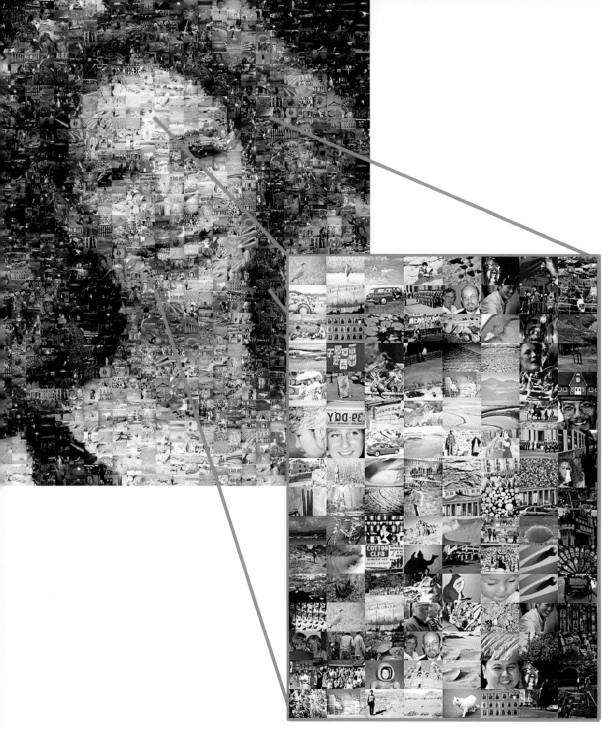

*The close-up section of this photo-mosaic
clearly illustrates how viewing distance effects
the appearance of pixels in an image.*

Viewing Distance
Influences the Appearance of Pixels

Viewing distance has a great influence on the appearance of pixels in an image. An image that has a pixel density of 100 pixels per inch may look coarse when viewed at a distance of twelve inches (30 cm) but at twenty feet (six meters) we will not be aware of pixels at all. This effect is the magic at work in the new photo-mosaic images that have become popular.

When viewed at a distance the primary image is quite apparent. When you get close you can see the many tiny little images that actually make up the pixels of the primary image. If you are aware of the pixels in an image at the intended viewing distance then that image can be said to be a low-resolution image for that distance. Viewing distance is not often fixed and so you want to be sure that your images look good at the closest distance from which they are likely to be viewed.

This is the most perplexing aspect of digital imaging and it is at the heart of the question: How much resolution is enough?

Changing the Pixel Count with Bicubic Interpolation

It turns out that there are many ways to increase the pixel count of an image to suit a particular viewing distance. Re-scanning a transparency to a higher pixel count is one method favored by prepress services because by doing that they can also take advantage of their high-end scanners' CMYK conversion and unsharp masking capabilities to improve the print reproduction of the file. You can achieve a similar kind of image scaling in Photoshop using bicubic interpolation. This is a fairly sophisticated method of averaging the value of two adjacent pixels to put a pixel in between them and expand the size of an image. This does far less damage to the quality of an image than projecting an image through a lens onto photographic paper although the type of quality loss is similar— the image loses focus. How far can you take this? What is the minimum pixel count possible and what is the ideal resolution for digital images printed at a given size? That depends on a number of factors. There is no hard and fast rule but, more often than not, you can get away with less than what is commonly recommended.

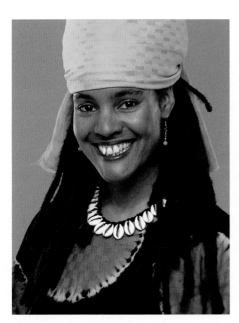

Original image at 300 dpi

Face scaled 200 percent using bicubic interpolation.

Eyes and mouth at 400 percent. Digital camera files can often be used at extreme magnification if they are properly scaled using bicubic interpolation with judicious unsharp mask.

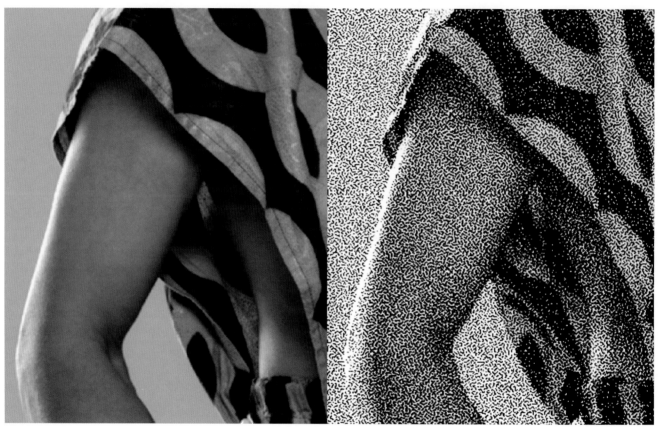

Continuous tone Dithered tone

Reproduction Methods Influence the Appearance of Pixels

All of our concerns about resolution in digital images center on the different methods of reproducing those images so that they are intelligible to the human eye. Continuous tone methods like photographic prints are an ideal way to present any image. Usually a continuous tone printer, like a dye-sub printer, is capable of printing at 300 pixels per inch (254 mm). A Fujix printer, which uses photographic material similar to type-R paper, can print up to 400 pixels per inch. Here more pixels per inch will always look better but in practice it is hard to tell the difference between 320 ppi and 400 ppi because 320 pixels per inch is close to the resolution threshold of the paper (put a loupe down on a Fujix print to check it out for yourself). While you can certainly make a case for an image that has a lot of fine straight diagonal lines in it, 200 pixels per inch is usually the minimum resolution for an image to appear smooth and unpixelated at a twelve-inch (30-centimeter) viewing distance with a continuous tone print.

Images printed with dithered tone methods are another story. Dithered tone is any method that achieves the appearance of continuous tone by placing a limited number (usually four to six) of colored dots in close proximity and varying either the size or the density of the different colored dots to visually mix different colors. For reasons that will become clear later it is harder to define the discreet pixels of a digital image with clusters of different colored dots than continuous tone methods. Various clusters of different colored dots are used by all ink on paper methods to reproduce pixels of a digital image.

Line Screen

Traditional offset lithography uses a method of dithered tone generally referred to as a line screen. This is a regular pattern of cyan, magenta, yellow, and black dots arranged in clusters called rosettes where the distance between the centers of the dots is fixed and the size of individual dots varies in order to change the overall balance of color of the rosette.

Line screens are identified by their resolution, which is given by the number of lines per inch that the screen can reproduce. Thus, a 150-line screen can reproduce 150 lines per square inch. It is easy to see that if you have black lines against white that are a single pixel in width, you need to put a single pixel line of white between the black lines in order to see lines at all. So, double the lines to come up with 300 pixels per inch for a 150-line screen.

This is a little misleading because although it may be true for black lines on a white background it is not easy for a traditional rosette to resolve light brown lines against a dusty green background.

Thus, "line screen" is not a very meaningful measure of image resolution. In order to clearly resolve the individual lines in this example you must have larger pixels so that more dots of ink are used for each line.

This is where it is clear that pixels are not dots.

Black lines on white

Brown lines on green

Brown lines on green

Ink Dot Clusters Define Pixel Colors

Actually, we need a certain minimum of different colored ink dots in order to define the color of a pixel. The dusty green color of a single pixel will need a mix of cyan, magenta, yellow, and possibly black dots to fully define its color. Subtle differences between adjacent pixels are averaged together in the pattern of dots and a higher pixel density for a line screen will result in a narrower range of tones reproduced because more pixels are averaged together for a given dot cluster. In practice there is a trade-off between image detail and tonal range. A digital image can easily contain a smooth gradation that has a full 350 different tones per inch. A 175 line screen (imaged on a 24000 dpi Imagesetter) is never going to be able to distinguish more than 180 or so of those tones; single pixel values that close together will be averaged together in the rosette pattern. If you are after maximum tonal range you can see that often "double the line screen" is actually wasted resolution. Scitex recommends a pixel density of 1.6 times the line screen; for a 150-line screen that would be 240 pixels per inch. Scitex CT files are generally figured at pixels per millimeter and 240 ppi falls between res 8 (232 ppi) and res 10 (254 ppi), both are considered acceptable for a 150 line screen. Black line art, on the other hand, will seem a bit coarse unless it is imaged at double the line screen. For some types of imagery 150 pixels per inch can actually look better on a 150-line screen than 300 ppi.

175 lpi = min 200ppi, max 350 ppi

133 lpi = min 150 ppi, max 266 ppi

150 lpi = min 180 ppi, max 300 ppi

Let's look at resolution as it applies to stochastic screens. A stochastic screen is a method of dithered tone that uses varying density of same size dots to achieve the appearance of continuous tone. A good example of this occurs in the Epson ink jet printers. The original Epson Stylus Photo printer was an instant hit with photographers because it was a very inexpensive printer that made very impressive photoreal color prints with six colors of ink dots. The resolution of the printer was advertised as 720 dots per inch (254 mm) and many photographers, including at least one reviewer, immediately tested the printer with huge 100 megabyte 720 pixel per inch files. 720 dpi for the Epson printer means that the printer is capable of putting 720 individual dots close together in 1 inch.

However, if we divide that by the number of different colored dots (six) we get 120, which is the maximum number of six-color clusters in one inch. Unless the color of a pixel matches one of those six ink colors, you are going to need at least three different dots to fully define the color of that pixel. So divide 720 by 3; now you have 240, which turns out to be the same resolution that Scitex recommends for 150 line screens. In fact, using any more than 240 pixels per inch in an image printed by this printer is a waste unless we have extremely fine detail with limited tonal/color range (such as black-and-white line-art).

To review:

Digital images are made up of discreet squares of color called pixels. Pixels have no inherent size and so the resolution of digital images is always expressed by the number of pixels per inch (or millimeter) at a given image size. Images can be considered to be low-res when the observer is aware of individual pixels in the image at a viewing distance considered normal for that image use. Continuous tone methods for printing pixel images can define each pixel with a solid color and can easily handle pixel counts up to the maximum the printer can handle without loss in quality. Dithered tone methods (like traditional four-color printing) deliver the appearance of continuous tone by placing individual dots of color close together to visually mix colors. Tonal range in these methods is limited by the density of dots the printer is capable of placing on a page and how many dots are used to define the color of a pixel. The quality of an image reproduced by dithered tone methods is a trade off between image detail and range of tones.

Recommendations
for Transparency Output

So what is the minimum pixel density for good quality in a digital image and what is the ideal, or best pixel density? The answer depends on the device used to reproduce the pixel image and the size and distance at which we view the image. Small images reproduced with continuous tone methods will generally require higher pixel densities because they invite closer scrutiny. Larger dithered tone images require the lowest pixel density because they are viewed at greater distances (billboards are produced with a twenty-five line screen—they are viewed at a distance of fifty feet (15.2 meters) or more). Sometimes the pixel density is fixed by the output device and digital files will be interpolated to size for the device. Postscript printers will happily RIP (rastorize) files to the requested size regardless of the pixel count of the file so you have to be more careful about what pixel density you use for the size of the output. Practical considerations will often force us to pick a minimum pixel density for very large images and interpolate to a more ideal pixel count. Generally an image created at a pixel count near 4000 x 5000 pixels can be interpolated successfully to almost any size and still look good.

Remember that large images are viewed at greater distances and so will tolerate a lower pixel resolution. Some suggestions for various output devices follow:

Transparency output, like those produced on an LVT (a type of LED printer made by Kodak), generally requires the highest pixel densities because they are almost always used for larger sized reproductions, whether by projecting an image on a big screen or by re-scanning for a large size print. A minimum resolution of res 20 (508 pixels per inch) or 3810 x 4699 pixels for a 7.5 x 9.25 inch (19 x 23.5 cm) image with a maximum of res 30 (762 ppi) or 5715 x 7048 pixels for a 7.5 x 9.25 inch (19 x 23.5 cm) image works well on transparency film. Smaller image sizes like a 35mm slide may be better at higher resolution, especially if you are planning on projecting it on a large screen. For images at res 24 and lower, imaged on LVT, always have the service bureau double the resolution at output; this forces the LVT to use a smaller spot for the imaging light source and will result in a sharper image. If you are going to make a 4x5 transparency to use for a large Cibachrome print or a Duratrans enlargement, aim for at least res 48 (1219 ppi)—the resulting image will tolerate enlargement better.

TRANSPARENCY OUTPUT

SIZE	RESOLUTION		PIXEL DIMENSIONS
	Scitex Metric	Pixels Per Inch	
8 x 10 min res.	Res 20	508 ppi	3810 x 4699
8 x 10 max res.	Res 30	762 ppi	5715 x 7048
4 x 5 min res.	Res 24	610 ppi	2134 x 2743
4 x 5 max res.	Res 48	1219 ppi	4267 x 5486
35mm min res.	Res 40	1016 ppi	1016 x 1422
35mm max res.	Res 60	1524 ppi	1524 x 2134

PRINTING RESOLUTION

TYPE & SIZE	MAX PPI	MIN PPI	IDEAL PPI
Fujix prints 8.5" x 11" and 11" x 17"	400	133	320
Light-Jet up to 50" x 50"	305	100	150
Iris ink jet 11" x 14" and smaller	300	150	300
Iris ink jet—larger up to 30" x 40"	300	100	150
4-color 133 line screen	266	150	175
4-color 150 line screen	300	175	240
4-color 175 line screen	350	200	300
Large format ink jet—up to 60" x 240"	240	100	100
Epson Desktop ink jets	360	180	240

Recommendations
for Printing Resolution

Fujix prints look best at 320 ppi but can often tolerate 200 ppi images well. Large Light-Jet prints can be prepared at 150 ppi and interpolated up to the maximum device resolution of 305 ppi at output (have the service bureau do it). I have seen good results with 100 ppi files (scaled 300 percent). For practical reasons it becomes difficult to deal with 50 x 50 inch (127 x 127 cm) images at 300 ppi so do yourself a favor and work on a smaller file—interpolating even 400 percent can work with some images. Work larger Iris ink jet prints at 150 ppi and have the service bureau scale 200 percent to 300 ppi. For smaller sizes on watercolor paper, there's no need to work higher than 200 ppi; with glossy stock stick with 300 if you can—all files will have to be interpolated to 300 ppi at size regardless.

Standard SWOP four-color printing at 150 line screen is generally best at between 200 to 300 ppi but not higher; interpolate down if your file has a higher pixel density at the size you want. Again, for poster size images you can work at 150 ppi or even 100 ppi and interpolate up for output. One more thing to consider: printers invariably overstate their capabilities and understate the dot gain on their press. This means that if the printer says they can print to a 175 line screen, chances are the job will print better with a 150 line screen.

Encad and other large format ink jet plotter prints will not require higher than 100 ppi because the coarse dither of their stochastic screen will obscure any pixilation and higher pixel densities will not improve the tonal range of the prints. In general, anything intended for large output like signage, trade show displays, banners, and outdoor murals can be used at 100 dpi with surprisingly good results.

A good rule of thumb for desktop inkjet printers like the Epson is to divide the output resolution by 3 or 4 (720/3=240 ppi. 1440/4=360 ppi). Larger 17 x 22 inch (43 x 56 cm) prints on something like the Epson 3000 can look fine at lower pixel counts depending on the paper used (fine art watercolor paper requires less resolution than glossy coated paper).

Image Quality

In conclusion, I would like to point out that the perception of quality in digital images has less to do with the resolution of that image at a given size than the tonal range and color subtlety of the image. The type of image also greatly influences the appearance of pixilation in the image; a shot of highly detailed metalwork with fine engraved lines will require a higher pixel density than a nude with moody lighting.

Many people will turn their nose up at the typical eighteen meg digital camera file because they claim that it isn't "like a hi-res scan from real film." This is ludicrous—a sixty-meg scan from a 35mm original only serves to resolve the dye couplers in the emulsion of the film (you get greater grain detail) without adding any image detail. That same eighteen meg digital camera file can be interpolated to 200 percent, has virtually no grain, and can look better at 11 x14 inch

(28 x 36 cm) on a continuous tone print than the grainy 35mm slide printed on type-R paper. You have to be aware of the final use of the image and its intended viewing distance before you can make blanket judgments on resolution requirements—most commercial uses just don't require such high resolution. This is not to say that real film is inferior—it's just different. Photo-digital imagery really is a different medium and because of the nature of digital output, lower resolution images can work just as effectively to communicate a full range of visual information as higher-res analog output like regular photo prints.

In digital images, sometimes less is more, but more often than not, it is more than enough.

TIME CONSIDERATIONS FOR A DIGITAL SHOOT

Be aware that certain things will go faster at a digital shoot and this should be considered when scheduling the arrivals of support staff and talent. It may be a pleasant surprise when you find that shooting the first model is done in half the time but you may be irritated when everyone is sitting around waiting for the next scheduled model to show up. Sometimes you cannot rely on the photographer's experience to help because they may intentionally "drag out" the shoot to make you feel that you're getting your money's worth out of the day rate. If you'd rather go home early, talk to the photographer ahead of time and assure him or her that you won't feel cheated if

"Alarm Clock" © Kim Simmons

you get to leave at 2:00 instead of 5:00. It can be a big help if you can bring digital files along for reference. If you have a preliminary Quark layout, bring it! Scan your thumbnail sketches on your flatbed and bring the files with you to the shoot. Most photographers shooting digitally should have the necessary software to accommodate you and it can be an incredible luxury to be able to place images into a layout right after you capture them. Thumbnails can be used as a template for composing the photos right on the computer (see Quick Tip in the next chapter, page 80). It is best if you prepare these materials ahead of time so that the photographer doesn't have to waste any time scanning or shooting these things at the shoot.

One final thing before the shoot itself is to make sure that the designer and photographer are on the same page as far as color evaluation. Photographers are used to being technical about color and digital shooters generally have serious monitor calibration systems in place. The designer needs to make sure that she is seeing color the same way on her computer.

Monitor calibration is the beginning of any color control system and the designer should consider how to calibrate a monitor before the shoot begins. This way you can train your eye to evaluate color on the monitor and there will not be any surprises when you return from a shoot and start working with images back at your worksta-

tion. Before going any further you should see to it that you have established a neutral environment for evaluating color...*Change your desktop picture to a neutral gray!*

I am always amazed at the incredibly colorful desktop patterns and pictures that most designers use as their computer desktop image. If you are constantly looking at images against a bright blue background your judgment of color will definitely be biased towards the cool side simply because every color you look at will appear warm in comparison to the blue background.

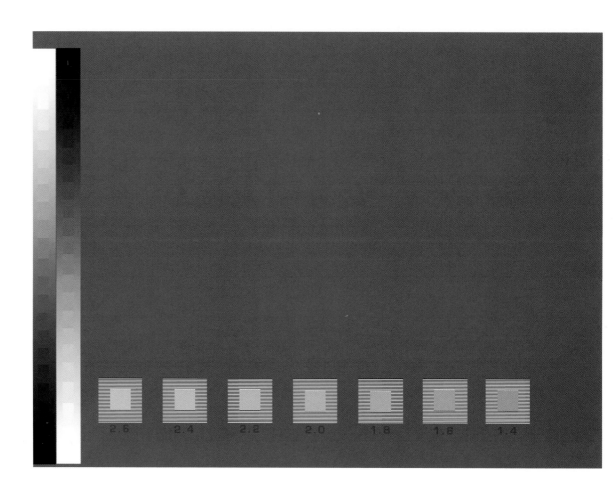

To the left is an example of the desktop picture that I use:

Besides your desktop picture, be aware of brightly colored objects in the vicinity of your monitor; the color of the wall behind the monitor and your desk could also affect your judgment. Once these issues are dealt with you can begin calibrating the display.

I have yet to meet a designer who had invested in a hardware calibrator but, even if you do not wish to spend money on this sort of thing, there are visual calibration methods available for little or no money. Apple's Default Calibrator is a component of the Monitors and Sound control panel and is standard on all Macintosh systems. This step-by-step Wizard interface helps you establish a basic gamma and color temperature for your display. The next step up in precision, Adobe Gamma, is also free.

Note the step wedge at the left and the row of gamma squares along the bottom. This allows you to get a fix on your monitor gamma at a glance without launching a calibration utility. You can grab these squares by taking screenshots of the Adobe Gamma calibration software at different settings (see page 70).

Quick Tip:

MONITOR CALIBRATION

Adobe supplies a software calibration utility called "Adobe Gamma" with all of their graphics software packages. This can be run as a stand-alone application or placed in the Control Panels folder making it readily available from the Apple Menu. The first time you open Adobe Gamma you are presented with...

Choose the step–by-step method; this will walk you through all the necessary steps to achieve calibration and give you a useable profile for your monitor. After you do this once you will probably want to just use the control panel directly.

Adobe Gamma opening screen

Adobe Gamma control panel

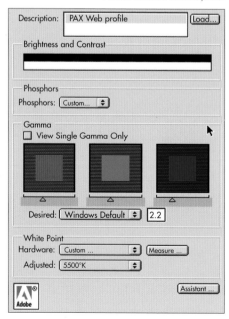

CONTROL PANEL

Starting at the top: if you click on the load button located at the top right corner of the control panel you will have the option to select any of the RGB profiles in your ColorSync profiles folder (inside the system folder, Mac OS 9+). This is useful for keeping track of different monitor calibration/profiles that you might create for different purposes. If you followed the assistant the first time through, you will find the name that you saved the first calibration settings under here.

One important note here: when you use the assistant you are asked to give settings a name at the beginning of the process and then asked to save a "profile" at the end. If you give the profile a different name at the end, when you click "load" in the control panel you won't find the settings "name" in the ColorSync Profiles folder, try as you might! Instead, load the "profile name" you saved at the end of the process to re-load the first "settings." It is probably best to keep the "settings" name and the resulting "profile" name the same to avoid confusion. You can load any RGB profile into the Adobe Gamma control panel but

it is best if you stick with monitor profiles. If you happen to have a monitor that matches one of the defaults supplied with your system software, you can go ahead and use it as a starting point. I think it is best, however, to save a new profile under a different name when finished and use that one in the future.

1

BRIGHTNESS AND CONTRAST

Next, you will notice the "Brightness and Contrast" bars just below the description box at the top of the control panel. You should be able to just barely see the separate checker boxes in the black bar with the white bar pure white. If you can't see separate boxes, then either the monitor isn't bright enough or the contrast is too high—or some combination of the two. Use the hardware controls on the monitor; try for a maximum contrast first and then set the brightness up until you can just see the difference. You might have to return to this after adjusting the gamma and color controls.

2

PHOSPHORS: The Elements in the Monitor that Make It "Glow"

The phosphors are the next consideration. Again, the assistant generally attempts to guess the type of phosphors for your monitor and if you aren't certain, you should probably leave this where you find it. If you have an Apple monitor and you started with one of the default profiles that matched your model, then the appropriate phosphors will be selected automatically. Sometimes you can get specific information from the monitor manufacturer in which case you can select "custom" from the drop down menu and you will then see the custom phosphors dialog.

You can enter the numbers you got from the manufacturer here.

	x:	y:
Red:	0.595	0.339
Green:	0.276	0.582
Blue:	0.147	0.059

Custom phosphors dialog

3

GAMMA: The Overall Brightness or Darkness

The next step is to set the desired gamma. Gamma is an overall brightness adjustment applied through a curve rather than the simple "gain" controls in the monitor hardware. The idea is to change the linear response of the monitor to something that more closely approximates the response of the human eye/brain to light. First, pick an aim point from the drop down menu beneath the color squares. There are many arguments as to the best choice but basically you can use either the Macintosh default of 1.8 or the Windows default of 2.2. For years, many experts recommended that you use a gamma of 1.8 for print work and 2.2 if the final use was screen display or output as slides. Ever since the fundamental change in Photoshop's color management, starting with version 5.0, this choice has become irrelevant. As long as you save a reasonable profile (the description of the monitor colors) at the end of the calibration routine for the monitor, in either gamma, Photoshop will modify the display to give you a decent preview of the image file. There are several theoretical reasons for choosing 2.2 over 1.8 but in practice it has little impact. I suggest using 2.2 unless you feel that everything else (other applications or the user interface in general) just looks too dark. The level of ambient light you work with can have a huge impact on how bright you perceive your monitor to be. Generally, the ambient light in the photo studio will be very low during shoot conditions and the photographer's monitor may be set at a gamma of 2.2. The lighting levels at your workplace may be much higher and you may find a better match using 1.8

Once you have picked the aim point, you can start adjusting the sliders. Start with the single gamma first. Check the "View Single Gamma Only" box and then move the slider under the gray square until the inner square matches the brightness of the outer square. It helps to squint your eyes a bit. Now uncheck the "View Single Gamma Only" box and start working on the three RGB colored boxes. It is relatively easy to get the red and green boxes set but the blue box seems to match a wide range of settings. I tend to use the blue slider to adjust the overall warmth of the color once I get red and green equaled out. It is particularly helpful to have an image with a good range of neutral tones on screen while you are adjusting these settings. You can have it open in Photoshop or any other application while you are adjusting the monitor with Adobe Gamma. Try to use a grayscale image so that you can be sure that there is no color bias in the gray tones.

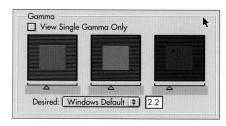

Adobe Gamma control panel

4

WHITE POINT: The Color Temperature of White

If you can set the hardware white point using the controls on your monitor, do that first. Usually, I recommend 6500°k rather than the proofing standard of 5000°k. Most monitors look too yellow at the 5000° setting and actually, by setting the monitor at 6500° you get a better visual match to a proofing viewing box with a 5000°k light source. After you set the hardware controls on your monitor, you can select the same setting in the "Hardware" drop down menu in the "White Point" area of the control panel. Next, pick the desired setting in the "adjusted" drop down menu. You might not have a choice to use 6500°k in your hardware or you might feel that 5500°k looks better. In either case, you can choose a setting that doesn't match your hardware white point. Sometimes you are stuck with a monitor that doesn't have controls for the color temperature. In this case, click on the "measure" button. You will be presented with a black screen and three gray squares.

The idea here is to click on the square that looks the most neutral (not too warm and not too cold). If you click on a right or left square, you will get another screen with three more squares; you get to keep on choosing until you pick the middle square, then you will be returned to the control panel where a hardware white point will be set for you. Many people have a great deal of trouble deciding on which gray looks most neutral in these tiny squares. If you are having trouble, you can ignore the measure button and simply select 9300°k from the drop down menu—the vast majority of monitors use this as a default color temperature because it makes the monitor look brighter.

The last step is to look at your gamma squares again and do a final tweak of the colors. When you are satisfied, close the window; you will then be asked to save your settings. Save the settings under the same name you picked in the Control Panel earlier and overwrite the previously saved settings in the ColorSync profiles folder. Congratulations! If you have carefully followed all these steps, you will have a more accurate display than at least 80 percent of the other designers out there!

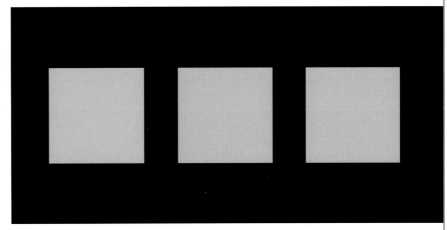

Adobe Gamma gray squares

5

A Few More Options

Before leaving this discussion I'd like to mention some other calibration options for you to consider: The relatively inexpensive application "ColorBlind™ Prove It!" from itec Imaging Technologies provides a more elaborate visual calibration method that can deliver more accurate calibration and profiles. As a bonus, this software also includes a very complete explanation of ColorSync color management in the form of an online guide written by Joseph Holmes, a fine art photographer and color guru. You can also use the software with a hardware calibrator, which you can purchase later or as part of a bundle with the software. One of the best hardware calibration systems is currently provided by ColorVision's "Optical" software with any of a number of colorimeters from X-rite, Minolta, GretagMacbeth, or ColorVision's own "Monitor Spyder." This package is very complete and provides an accurate and convenient method of calibrating and profiling multiple monitors.

The "Optical" software with monitor "Spyder" provides an accurate and convenient method of calibrating and profiling multiple monitors.

PRE-PRODUCTION CHECKLIST

Determine image sizes for final use

1

Prepare layouts or aspect ratios for shots

2

Determine print conditions and resolution needed

3

Calibrate your monitor

4

Relax

5

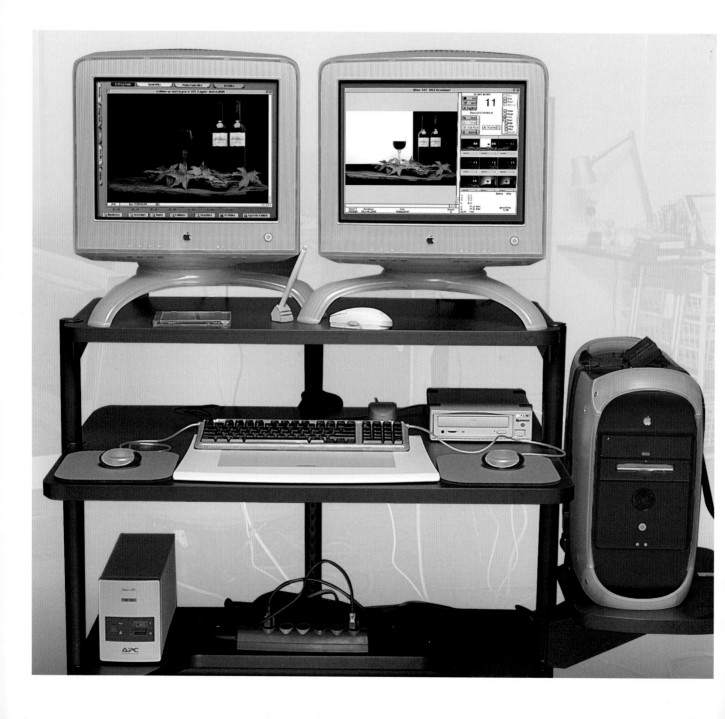

WORKSTATION/CAMERA CONFIGURATION

Most of the time, digital photography can be approached the same way as traditional film-based photography: discuss layouts, set up lighting, and pose or position subjects. The main advantage of the digital shoot is that test images are shot and displayed instantly on the computer monitor instead of waiting a minute and a half for a Polaroid shot to develop. The photographer does not have to worry about running out of film and can shoot more tests in less time allowing you to zero in on the desired effect faster.

If you need to match the lighting or positioning of image files on hand, set up a dual monitor for the camera workstation. That way you can have the image you are trying to match up on one monitor with the new image captured on the monitor next to it. If the camera workstation is set up with a Wacom tablet for on-the-spot retouching, it should be networked with one other computer that is set up with design software and an active connection to the Internet. Frequently, there is a need to do other things on the computer during a shoot and this second computer frees up the camera workstation for photography.

If you have Quark layouts handy, you can use the second computer to drop test shots into the layout to check for positioning against other graphic elements or modify the design to take advantage of serendipity at the shoot. You already saw how transferring files over the Internet can be done and having another computer available for E-mail and FTP activities during the shoot allows you to keep shooting while files are being transferred. If the photo studio does not have a second computer available, bring a laptop computer along to the shoot—it can make things go a lot more smoothly.

Two 17-inch (43 cm) monitors are better than one 21-inch (53 cm) monitor on the camera workstation. The second monitor allows for easy comparison of shots for matching purposes; ideally, both monitors should be identical so color can match better.

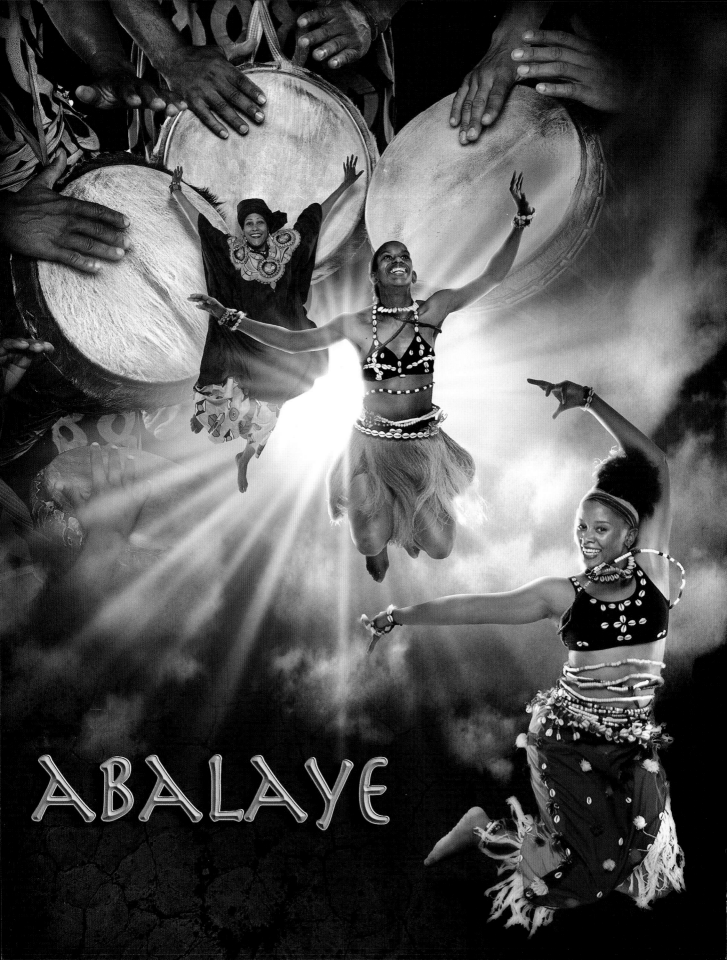

Layout Templates

Layouts and thumbnails can be used very effectively on a digital shoot. Many of the three shot cameras that have live video focus and preview also have the capability to superimpose a thumbnail "template" on the video image. This allows for very precise positioning and matching perspective, especially if the shot has to be used with pre-existing elements. Even if the camera software doesn't support the use of superimposed templates, you can achieve something similar in Photoshop.

This poster for the African dance ensemble, Abalaye, was shot with a Megavision S2 camera. Fifteen different setups were shot in one day in the studio with choices made by a group of eight dancers on the spot. The final elements were later assembled in Adobe Photoshop.
Abalaye by Lee Varis © 1998

Abalaye individual elements © Lee Varis

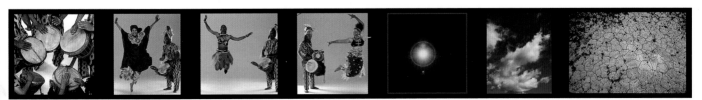

USING LAYOUT TEMPLATES
IN PHOTOSHOP

Scan the thumbnail sketch or, perhaps even more convenient, simply shoot a picture of the sketch with the camera you are using at the shoot—that way it will automatically be the right size because the pixel dimensions of the camera CCD are fixed.

Shoot the first test, eyeballing the sketch to get an approximate composition.

1

Next, open this shot in Photoshop and open the digital template file as well. Using the mover tool, drag the template onto the photo. You should now have a layer with the template sketch above the first test photo; you can lower the opacity to something like 60 percent (see #3) to see the underlying image.

2

At this point, adjust the position of the template layer to get the closest match. Many times it is easier to see an underlying image if you make the white background of the sketch completely transparent and force the black lines to some contrasting color. The simplest way to do this is to go to the layer pallet and select "Blending Options."

3

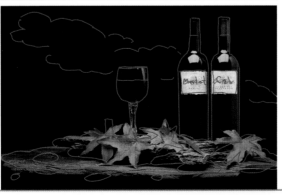

You will be presented with the "Layer Style" dialog box: Adjust the "Blend if Gray"—"This Layer" slider by dragging the white triangle to the left. You will see the white part of the sketch layer disappear revealing the underlying image with the black lines on top of it. (In this example, the black lines have already been changed to blue so that they show up against the black background of the photo.)

You may notice some white fringe at the edges of the sketch lines; you can eliminate these by holding down the option key and "splitting" the triangle slider— move the left half further left to smooth away the fringe.

Once this position template is set up, successive shots can simply be dragged into this document to check adjustments. Hold down the shift key when dragging and the new layer will automatically be aligned with the previous shot. Position any new shots under the template layer and you can easily make precise adjustments and compare between versions by turning layers on and off.

4

Art director's line drawing

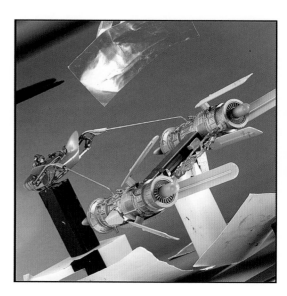

Two different angles were shot of the Pod Racer toy to get the ideal angles on the major components—this version was used for the engines. A higher angle was shot for the cockpit and the two versions were composited together.

Precise Positioning

Kim Simmons of Simmons Photography has used templates to good effect and saved time in the process:

"I was well into shooting the new *Star Wars®* toy line when Hasbro™ requested a major change. In this case I had just finished shooting the Pod Racer toys and I had to re-shoot all of the shots for one of the packages because that Pod Racer had to face the opposite direction.

"My problem for the shoot was that they had no time to redesign the layout—it was going to be done, on the fly, in camera while we were taking the photos. The art director came to the studio and, using a line drawing on the monitor, we were able to shoot and reshoot until we got the angle of the Pod Racer he needed. It had to fit around type that had to be in very specific places on the package for the legal department.

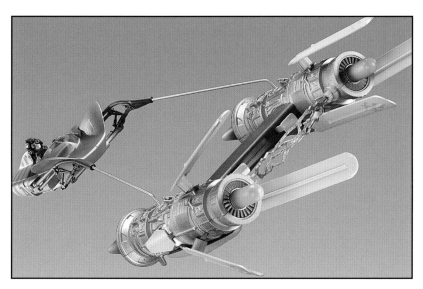

Star Wars ® *Pod Racer final composite shot*

Star Wars ® *Pod Racer finished package*

"This was repeated for the rest of the photos, although for the last few images, he just held the Pod Racer for me while I took very low-res images in the position he envisioned. I then shot the hi-res images, after he left, using the lower-res files as a template. I then E-mailed PDF files of each photo to him for approval. He phoned me with any corrections he needed and we talked our way through them."

One of the features of digital image capture that allows you to use image templates in the manner just described is that each successive shot taken with a digital camera will be in perfect registration with the previous shot—assuming that the camera has not moved between shots. This allows the creative team to utilize a new strategy for lighting still life subjects.

The following special step-by-step technical section will outline in detail the construction of a tabletop still life shot using this approach with digital photography and Photoshop.

Painting with Digital Light

One of the many benefits of digital image capture is that each successive shot taken with a digital camera will be in perfect registration with the previous shot—assuming the camera has not moved between shots. This allows the creative team to utilize a new strategy for lighting still life subjects, and an endless range of possibilities. The following step-by-step technical section will outline in detail the construction of a tabletop still life shot using this approach with digital photography and Photoshop.

This image was created using digital-capture and Photoshop's layer blend modes (a layered lighting technique). Digital-capture opens up a whole new way of photography in the studio, and complex lighting like this becomes easy to achieve. The key to this procedure is locking down the camera on a tripod so each separate image is in perfect registration with the previous image. By allowing for creative feedback during the photographic process, the range of effects becomes more dynamic because images can be manipulated in the computer as you are capturing them.

LAYERING MULTIPLE IMAGES

The basic idea is to shoot each different lighting direction separately, then blend them together in Photoshop by stacking the layers one on top of the other. Because different blend modes control how the layers interact with one another, it's important to start with the bottom layer and work your way up.

In this case, the bottom image is a stock shot of a sunset sky, and the image that will be blended over it is the silhouette of the bottles against a white background.

The result is a composite image with dark silhouetted bottles against a sunset sky. From here on, additional image layers will be screened over the underlying layers, gradually building up the lighting. Layer masks are used to control which part of each layer is used to build up the lighting. The result is similar to "Hosemaster" lighting, where light is painted over the subject with a special fiber optic light source. This Photoshop light painting is much easier to control, and because the results are immediately apparent, it allows for greater experimentation and a much tighter and more polished look.

BACKGROUND LIGHTING

The first step is to create a silhouette of the foreground objects by only lighting the background. Place a large white card (foam core) behind the subject keeping a fair amount of space between the white card and the foreground set – this will keep unwanted light from spilling into the foreground.

1

After you have this shot, go into Photoshop and drag the sunset sky file onto the wine silhouette image file (hold down the shift key as you drag in to ensure perfect registration); the sky should be pre-scaled to match the size of the wine file.

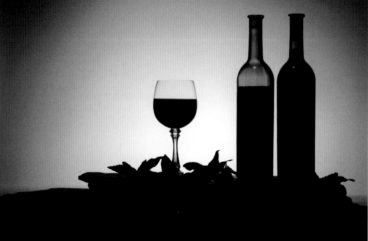

2

At this point you will not see the wine bottles because the sky is on top however, by changing the "layer apply" mode (the drop-down menu directly under the layer tab) to "multiply," the two images will blend, darkening the white card background with the image of the sky.

3

ADDING OVERALL FOREGROUND LIGHTING

In this case, overall foreground lighting will be supplied by a medium softbox. Change out the white background for a black one (black Tuflock) before you shoot and, assuming that the camera is locked down on a tripod, all the subsequent shots will be registered.

Change the "apply" mode to "screen" and shift-drag the new image with the overall foreground lit on top of the silhouette sky combo. The foreground light will now be added into the silhouetted wine set.

To control where the light is applied, add a layer mask to this top layer by clicking on the mask icon at the bottom of the layer pallet and inverting the mask to black (command-i).

Gradually add in the light by bringing up the levels dialog (command-L), and slide the black triangle at the bottom of the dialog to the right just a bit. This will gray up the mask revealing a little bit of the overall light.

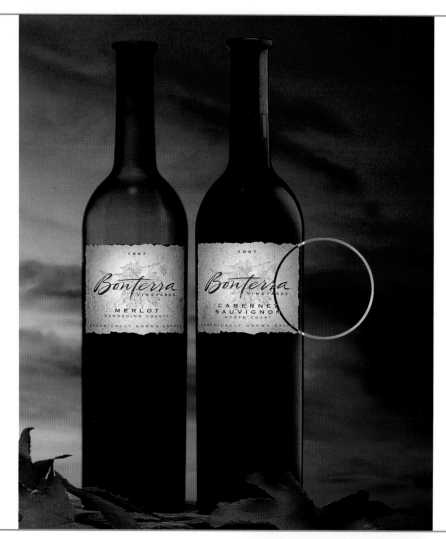

To add light where you want it, choose a soft airbrush and paint into the mask with white—in this case light was added to the labels and the right side of the wine bottles. Use a lower opacity setting (10-30 percent) with the airbrush to gradually build up light. Mistakes can be corrected by painting with black into the mask. Very subtle lighting effects can be achieved this way, blending different light sources, and building up the light one layer at a time.

8

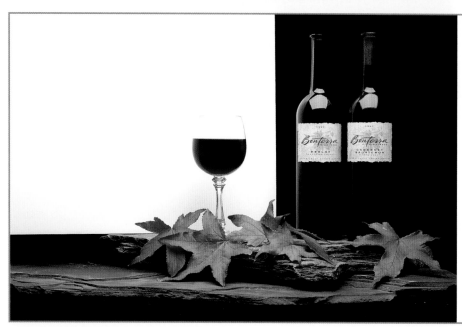

The next layer is a shot with a white card placed right behind the wine glass. Shift-drag this file over the composite, change "apply" mode to "screen", and create a layer mask to hide the layer. Now use the airbrush and paint into the mask with white to put a soft glow behind the glass.

9

Next, add the highlights from the left bottle. This layer mask technique allows a much freer placement of white cards and other light controllers because now you don't have to be concerned with these things showing up in the shot. Reflections and shadows can be created in the ideal position and simply painted-in to avoid showing the source.

10

This lighting set-up is used specifically for highlighting the leaves. Shift-drag this shot onto the composite, create a layer mask, and paint in the mask to create the dappled lighting effect. One thing to keep in mind is that sometimes where you don't see light is more important than where you do. Keep examining the light and only add to those areas that have very good light quality, like the highlights on the stem of the wine glass in this shot. Don't be afraid to change the intensity of the layer or even do a curve or levels adjustment in the new layer once you have the lighting in place. It's easy to see how the newly added light interacts with the rest of the image—make adjustments as needed.

11

The final layer brings in light from the left to add further texture to the stones and leaves. Proceed as before by shift-dragging the file over the composite, changing the "apply" mode to "screen," creating a layer mask to hide the layer, and painting into the mask with white. Because this light is in a separate layer, it is easy to change not only the intensity, but also the color of the light as well. Make sure you have the image layer selected and call up the "Hue/Saturation" dialog (command-u). Check the Colorize radio button and slide the Hue triangle to the desired color. This kind of control is much better than using gels over the lights.

12

FINAL ADJUSTMENTS

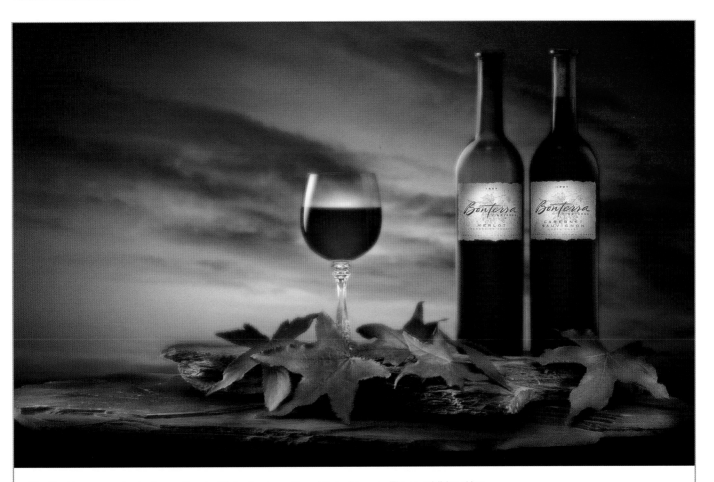

The final image can be further refined with "adjustment" and "blur" layers. These additional layers are treated the same way to create a layer mask and paint-in where you want the effect. In this image, the color of the wine was enhanced with a "levels adjustment" layer. This layer brightened up the red channel in the image by painting into the wine glass and the bottles with a soft airbrush. The subtle diffusion effect was created by duplicating the merged layers, running a "Gaussian" blur, and bringing this image over the rest of the composite at a reduced opacity. A layer mask can be used to further control the effect.

13

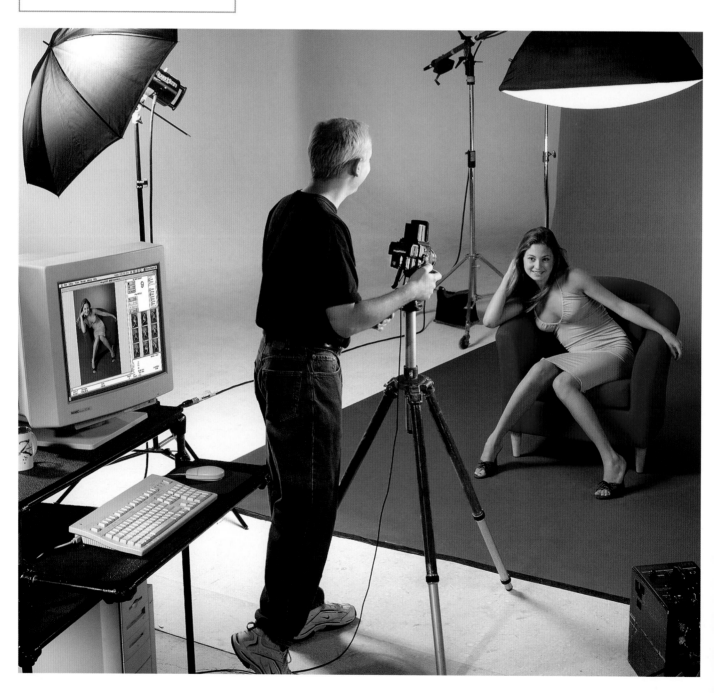

Digital photography of people can be especially gratifying in the studio. The instant feedback of digital-capture makes shooting fashion and portraits easier and faster than ever before. The art director and client can both view each shot as it is being taken and see all the action from the photographer's perspective.

The stylist and makeup artist quickly see the results of their work and any changes can be implemented without waiting for Polaroid confirmation. Shots displayed in a proof sheet view provide convenient comparison, making it easy to approve shots on the spot.

All professional single shot cameras have some provision for shooting to a proof sheet displayed on screen. Most often the display can be switched between full screen and proof sheet views. Here we can see variations in the poses of the model as viewed from a high vantage point; the photographer and camera were up on a 12-foot (3.7-meter) ladder, which, under normal circumstances, would make it difficult for the art director to evaluate the shot.

Shooting people in the studio with a single shot digital camera allows you to see every shot as it is captured on the monitor. Quick action and subtle expressions can be fine-tuned as you shoot because of this immediate feedback. Sessions go quicker because you can stop when you see the shot. Resist the temptation to watch the model and look at the monitor during the shoot; that way you will see exactly what the photographer is seeing as he shoots and it will be easier to art direct.

Marla Streb photographed by Gerald Bybee
for cover of Outside magazine.

Digital-Capture Promotes Spontaneity
Sometimes this quick display can allow the art director/photographer team to explore an alternative direction for the shoot as was the case in the following story from Gerald Bybee, a top photographer in San Francisco:

"We where doing a photo session for *Outside* magazine with Marla Streb, a mountain biker, shooting conventionally [on film] and I was just covering some parts of it with digital for convenience. At the end of the shoot the AD asked if we could do some quick shots with a wide angle lens. So I shot them with the Kodak 560 and a 17-35mm zoom lens. We cranked up the music, the fan, and I shot on the floor hand held from the front wheel. He saw the shot on the LCD and loved it. We immediately downloaded them and we put in a layout with the cover logo.

He went nuts and talked the editor into replacing the planned cover image with this low-angle studio shot. We wound up compositing two images together to get the front wheel from one frame and face and body from another. We deliberately didn't retouch her scars on her shin, although I enhanced the perspective. The compositing work was done in Live Picture and Photoshop."

Gerald Bybee

The Joy of Instant Approval

When the project involves subjects who must approve the photos to be used from the session, digital-capture can have a tremendous advantage. For example, shooting an album cover of a rock group right before they leave for their European tour in a traditional, film-based photo shoot means the group is probably on a plane over the Atlantic when the film comes back from the lab. Shots would have to be duped and sent to the hotel where the band is staying. The group would then have to set aside time in the middle of their hectic tour schedule to review the shots. At a digital photo shoot, the band can see all the shots before they leave the set and you can get approval before they disperse.

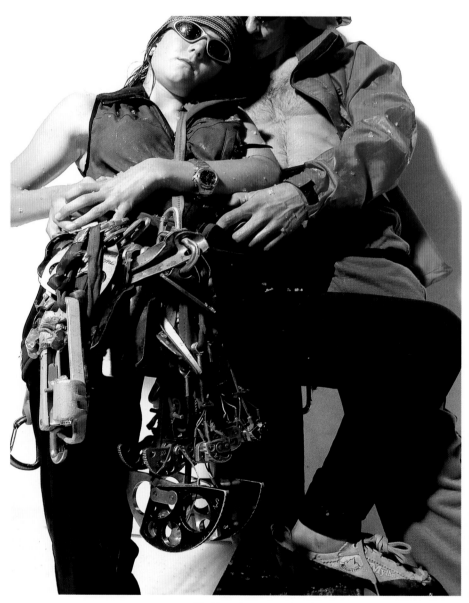

Climbiers photographed by Gerald Bybee for Outside *magazine.*

A New Dialog with the Talent

Digital-capture can be a big help for inexperienced talent as well. Shots that are displayed as captured give the novice subject immediate feedback so they can adapt to the direction offered by the art director or photographer. Gerald Bybee relates the following:

"Another project we did recently was a fashion spread using two young, inexperienced models (who were serious rock climbers) for a climbing fashion story. As we shot digitally, we created a rough of the spread together as we worked to sell to the editor who was in doubt as to the sexy nature of the images. The talent could see immediately what we were doing and it helped them understand their part."

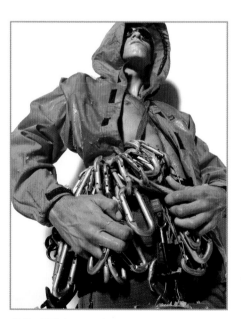

© Gerald Bybee

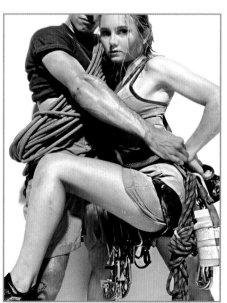

© Gerald Bybee

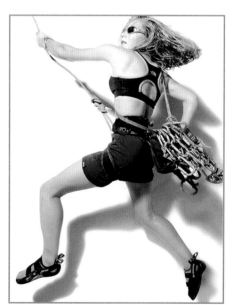

© Gerald Bybee

Outdoor Shots

Digital can work well at outdoor locations. Single shot cameras like the Kodak 560 or DCS-1 and Nikon D-1 cameras are especially well adapted to shooting outdoors because they can be used as self-contained systems (no need for a computer). This approach is more like a conventional film-based method because the tiny LCD previews offered by these cameras are marginally better than Polaroids. Most photographers bring laptop computers on location for evaluation of image files although proof sheets of shots can be produced later if a computer is not available at the shoot.

Sailing fashion proof sheet
©Gerald Bybee

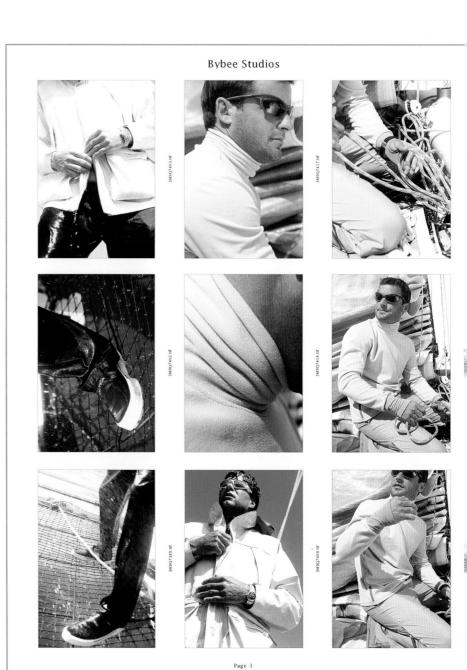

Bybee Studios

Page 1

Bybee Studios

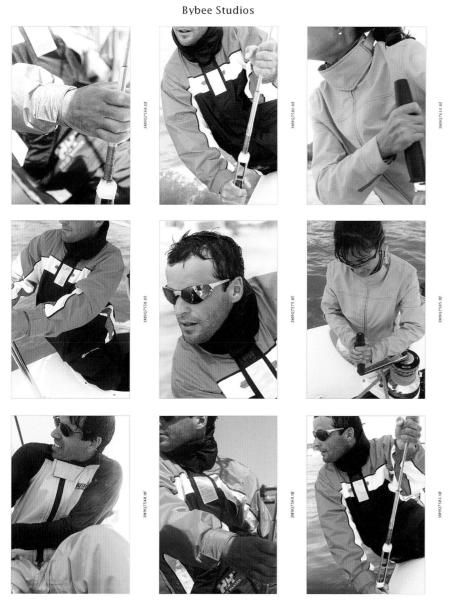

3M9Q7568.tif

3M9Q7580.tif

3M9Q7610.tif

3M9Q7558.tif

3M9Q7575.tif

3M9Q7585.tif

3M9Q7548.tif

3M9Q7569.tif

3M9Q7581.tif

Working on Location

Location photography presents special challenges not only for sensitive electronic equipment but also because viewing conditions in the field are often not ideal. Despite all this, cameras that require tethering to a computer can be used quite effectively with a Firewire connection to a laptop computer. Always try to have backup equipment available should disaster occur; photographers will always remember to bring extra camera bodies, lenses, lights, etc. but may not think about having an extra laptop computer handy!

Single shot cameras like the LightPhase can work very well at an outdoor location by tethering to a notebook computer via Firewire. Note the hood shielding the LCD screen from ambient light.

While the LCD monitor of the notebook computer is not as color accurate as a regular CRT in the studio, the instant feedback it provides for location digital photography is still very valuable.

On the Spot Special Effects

Digital-capture allows you to experiment with special effects at the shoot without committing to a particular look. It has become popular, especially with fashion photography, to "cross-process" film to achieve a special effect. This is normally done by developing slide film in negative chemistry. The resulting images exhibit exaggerated colors, contrast, and grain. While a certain amount of control can be exercised in printing, the technique is unpredictable and because you can't see what it looks like before the film is processed you never really know if it is going to work for a given situation. Also, once the film is cross-processed there's no turning back. You can achieve these kinds of altered color/contrast effects quite easily in Photoshop. By working up a few samples at the shoot you can see if it is a direction you might want to go in and adjust your shoot to fit the desired look.

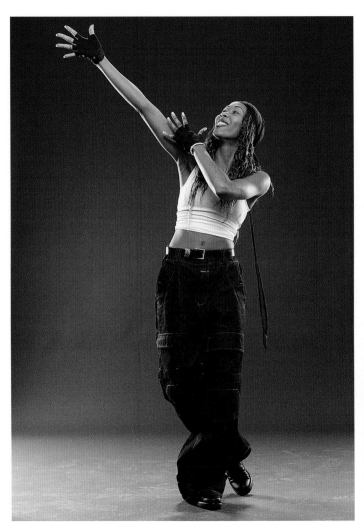

Original Vanya

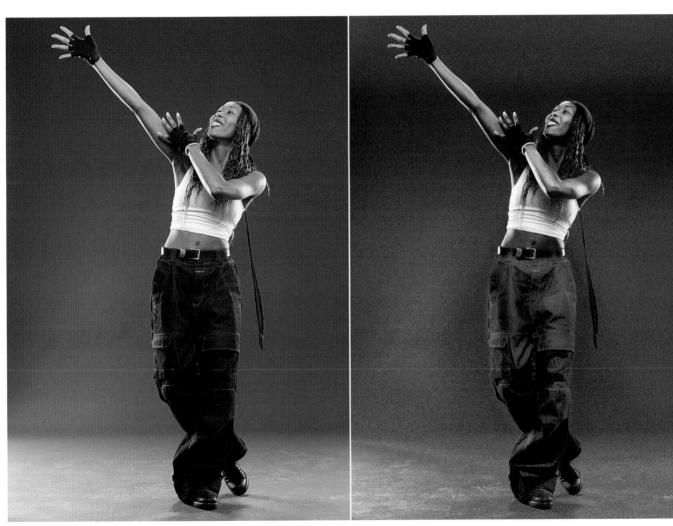

Alternate cross process effect

Extreme cross processing effects can be produced digitally with greater control at the time of the shoot, allowing for better pre-visualization.
©Lee Varis/Varis PhotoMedia

All kinds of digital "effects" are possible and shooting digitally allows the creative team to develop an image as they go along, combining multiple images as they are shot. Pekka Potka, a top advertising photographer in Finland, often works this way. In the following story, he describes a project he did with the art director Mikko Tarvonen:

Pekka Potka

"Voyeur" final small

"This project was for a brochure for Galerie Art paper. This particular image is one of five images that I shot for this assignment. It is at the beginning of the sample pages and so it had to portray their message of seeing very strongly. It started from Mr. Tarvonen´s idea of something rushing through a cutout in a previous page into the still intact lens in this photo.

"The other broken lens was to give an excuse to show the papers' physical handling properties. I wanted the person with the eyes to look very furious and wild. Furthermore, I wanted to make the image less literal by cutting her picture to pieces so that it is not so much a portrait of a person. I presented these visual ideas to Mr. Tarvonen and got his approval to go ahead with the assignment.

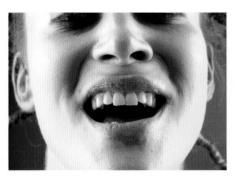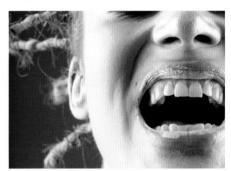

Several individual close-ups were captured with a one shot digital camera to construct the final image of the "wild" woman.

"We created the look for our model with the stylist and makeup artist and came up with these opticians glasses, which go hand in hand with the importance of seeing. I shot the image with a digital studio camera. Actually, it is a composite of numerous shots from two different cameras. The final image reveals several obvious pieces and then there are dozens that aren't obvious.

"The model was shot with a one shot back. The greatest benefit of digital shooting is immediate feedback. We could go through expressions on the monitor with the model and fine tune them. The model, Saimi, who works mostly in Milan, Italy, kept up the appropriate "wild" mood by cursing and shouting at me in Italian while I shot. She really was quite furious at times, brrr... I could check that I had enough overlapping frames for various parts of her head all the time while I shot. All this would have been totally impossible on film. We went through three versions of make-up and hairstyles. The final image actually has parts from all of them although it is mainly from the one we set as our main style. Then I shot the glasses on her from various angles to fit on the final composition.

"The model shots were against a red background to make silhouetting her blue hair easier. I wanted to be able to concentrate on her and added the background later at the manipulation stage. For the background, I shot a bunch of rusty metal plates, and several versions of a large scratched metal plate. These were shot with a three shot back.

"It may be very obvious that I got a huge number of images from this shoot. Here is another benefit of shooting digitally. They are all immediately usable. I just organized them with Canto Cumulus and chose from there what I needed. You can start post processing right away after a digital shoot. I use Live Picture for compositing. It makes building an image like this very convenient because there are no file size limitations like in Photoshop. I just started from an empty canvas and added piece after piece and tested how they fit together. If something did not work, I checked another one from Cumulus and went on.

"First I created a crude composite version with the red background still there. I E-mailed this one to the art director so that he can check how the image fits into the final layout with text in place. There were a few versions like this before I got the right pieces so that the limitations of layout were worked out while achieving the right expression in one composite.

"When I knew which pieces I was going to use, I silhouetted the model from red background in Ultimatte Knockout (an application that creates semitransparent masks) and layered the silhouetted model shots on rusty and scratched metal plate layers in Photoshop. Then, I added a few adjustment layers to alter and control the background color and opened my Live Picture composite with these new pieces in place. The rest was creating effects and fine-tuning in Live Picture.

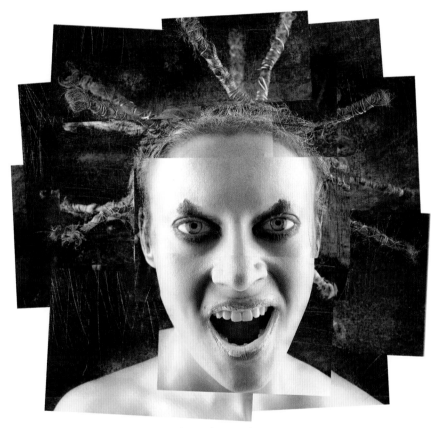

"Voyeur" face shown before work was done on the eyes.

"There are several details like the colors of eyes and white radiant eyelashes. The eyelashes are from another shot but the eyes are just color corrections although I shot a few contact lenses just in case. The broken glass is actually from a broken camera lens. It was broken several years ago by a flying stone in a rally race. I saved the lens as I thought it would be useful some day...

Detail showing the retouching done on eyes.

"I had free rein in this assignment after the original briefing but we were still able to work quite closely with Mr. Tarvonen. We were in contact all the time through E-mails so that he knew how these five images were progressing. In a work like this it is important to proceed in reasonable steps and check each other's opinions. Redoing lots of effects and fine-tuning steps is very time consuming.

"The aim of the sample was to hammer home a single main message and to demonstrate the paper's excellent printability. The message was: 'A person receives over 70 percent of all information in the blink of an eye. Galerie Art's ability to transfer information is almost perfect, close to ninety-five percent ...the whole truth and nothing but the truth.'

"The message had to be tailored into a modern package being able to reach both the printers and the graphic designers. That was successfully done. The client was pleased and the next sample is already at the drawing board. Furthermore, the trade magazine Paper Focus picked the sample from a pool of over 700 competing entries as "The Best Promotional Material of 2000" in its Paper Focus Awards in London."

Pekka Potka is one of the premier advertising photographers in Finland. He finds that digital-capture encourages experimentation allowing him to build complex composite images as he shoots and re-shoots elements. "Voyeur" by Pekka Potka, www.potkastudios.fi/

**POINT & SHOOT
DIGITAL STOCK**

Before moving on to post production issues we should explore the great potential that less expensive "prosumer" point-and-shoot digital cameras have for building a personal library of digital stock. Many designers utilize royalty-free stock photo CDs with generic imagery suitable for use as graphic elements. The new, under $1,000, digital cameras available in three megapixel resolution (roughly 1500 pixels by 2000 pixels) are more than adequate for 8.5 x 11 inch (22 x 28 cm) images—especially for textures and background elements. Numerous cameras like the Nikon Coolpix 990 or the Canon Powershot G-1 provide high-quality digital images in an easy-to-use, autofocus design.

These cameras completely replace Polaroid SX70 cameras for comps, location scouting, and general visual note-taking. They are also great tools for capturing your own custom digital stock photos. Every designer should keep one of these babies with them at all times. Great surface textures and backgrounds can be found everywhere.

What better background for that grunge look than real grunge—taken from an oven pan!

This unusual texture above comes from a tortilla inadvertently burned in a microwave oven.

Bamboo leaves (upper left)

Wood siding from a garage door (left)

Sky shots (below)

High-contrast images can often be quite effective as backgrounds when they are screened back as seen in the letterhead and business card to the right.

SHADOW PRODUCTIONS INC.

123 Example Street, Your City, ST 12345
987.654.3210.PH 987.654.3210 FX
www.yourwebaddress.com

August 16, 2???

Jane Smith
Creative Director
Advertising Firm
1234 Street Address
Your City, ST 12345

Jane:

Lorem ipsum dolor sit amet, consectetuer adipiscing elit, sed diem nonummy nibh euismod tincidunt ut lacreet dolore magna aliguam erat volutpat. Ut wisis enim ad minim veniam, quis nostrud exerci tution ullam corper suscipit lobortis nisi ut aliquip ex ea commodo consequat. Duis te feugi facilisi. Duis autem dolor in hendrerit in vulputate velit esse molestie consequat, vel illum dolore eu feugiat nulla facilisis at vero eros et accumsan et iusto odio dignissim qui blandit praesent luptatum zzril delenit au gue duis dolore te feugat nulla facilisi.

Lorem ipsum dolor sit amet, consectetuer adipiscing elit, sed diem nonummy nibh euismod tincidunt ut lacreet dolore magna aliguam erat volutpat. Ut wisis enim ad minim veniam, quis nostrud exerci tution ullam corper suscipit lobortis nisi ut aliquip ex ea commodo consequat. Duis te feugi facilisi. Duis autem dolor in hendrerit in vulputate velit esse molestie consequat, vel illum dolore eu feugiat nulla facilisis at vero eros et accumsan et iusto odio dignissim qui blandit praesent luptatum zzril delenit au gue duis dolore te feugat nulla facilisi.

Lorem ipsum dolor sit amet, consectetuer adipiscing elit, sed diem nonummy nibh euismod tincidunt ut lacreet dolore magna aliguam erat volutpat. Ut wisis enim ad minim veniam, quis nostrud exerci tution ullam corper suscipit lobortis nisi ut aliquip ex ea commodo consequat. Duis te feugi facilisi. Duis autem dolor in hendrerit in vulputate velit esse molestie consequat, vel illum dolore eu feugiat nulla facilisis at vero eros et accumsan et iusto odio dignissim qui blandit praesent luptatum zzril delenit au gue duis dolore te feugat nulla facilisi.

Best Regards,

Josh Black

JOSH BLACK

987.654.3210 PH
987.654.3210 FX
www.yourwebaddress.com
name@emailaddress.com

SHADOW PRODUCTIONS INC.
123 Example Street
Your City, ST 12345

SHADOW PRODUCTIONS INC.

BIG • SKY
LANDSCAPE DESIGN

August 16, 2???

Jane Smith
Creative Director
Advertising Firm
1234 Street Address
Your City, ST 12345

Jane:

Lorem ipsum dolor sit amet, consectetuer adipiscing elit, sed diem nonummy nibh euismod tincidunt ut lacreet dolore magna aliguam erat volutpat. Ut wisis enim ad minim veniam, quis nostrud exerci tution ullam corper suscipit lobortis nisi ut aliquip ex ea commodo consequat. Duis te feugi facilisi. Duis autem dolor in hendrerit in vulputate velit esse molestie consequat, vel illum dolore eu feugiat nulla facilisis at vero eros et accumsan et iusto odio dignissim qui blandit praesent luptatum zzril delenit au gue duis dolore te feugat nulla facilisi.

JOSH BLACK

987.654.3210 PH
987.654.3210 FX
WWW.YOURWEBADDRESS.COM
NAME@EMAILADDRESS.COM

BIG • SKY
LANDSCAPE DESIGN

123 EXAMPLE STREET
YOUR CITY, ST 12345

BIG • SKY
LANDSCAPE DESIGN 123 EXAMPLE STREET, YOUR CITY, ST 12345

Digitally captured photo textures and backgrounds can be utilized in a wide variety of applications. These photo-graphic elements can provide a lot of style for very low cost and their "personal" uniqueness is an added value.

BIG ● SKY
LANDSCAPE DESIGN

Shoot Your Own Stock Images

Could you make use of a sky photo? These are great for all kinds of uses and even fairly low-res shots can be scaled up and used at large sizes for backgrounds.

Once you get in the habit of carrying your camera around, you'll be surprised at how many great and simple design images you can get every day. You may never buy a stock photo disk again.

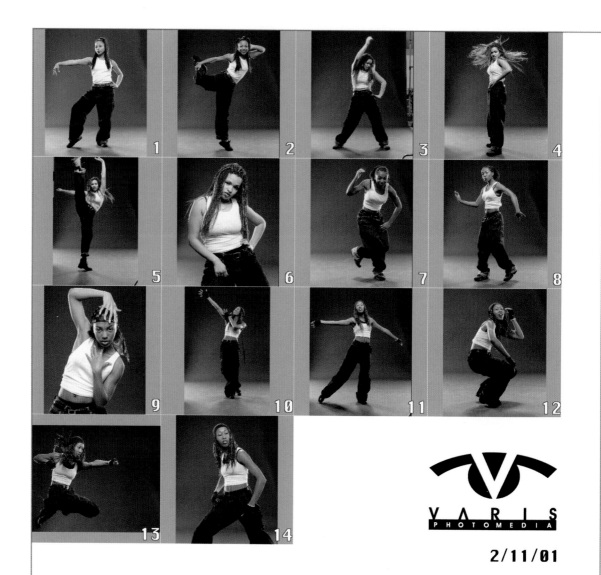

2/11/01

This proof sheet was designed as a cover for a CD of images. It was produced through the Imagebook plug-in for Photoshop (www.gamutimaging.com).

IMAGE SELECTION AND ORGANIZATION

Once you have completed the photography, the job of image selection begins. If you are doing product photography, image selection is usually simple enough that you can select final images as you go along. Photography of people presents a different challenge. When you are finally satisfied that you have the shots you need, quite often, you will have several gigabytes worth of image files on the hard disk. Ideally, a lot of redundancy can be eliminated during the shoot simply by deleting bad shots as you go but I have yet to meet an art director who was completely comfortable with that approach.

The tendency is to save everything and decide later—a necessary habit when dealing with film but this can rapidly become cumbersome with digital image files. The more files you decide to review later the longer it takes to batch process and write to disk. You also have to have some convenient method to review a lot of images quickly—opening them up one at a time in Photoshop just isn't going to cut it.

Fortunately, just about all single shot camera systems have extensive support for proof sheet views of captured files. In many cases, images are captured to the proof sheet and then "moved" or saved to a folder on the hard disk where they can subsequently be opened up into the proof sheet again. In my own work, I might save several "sessions" like this into separate folders.

Photoshop's own contact sheet (File-> Automate-> Contact Sheet II...) produces this layout. While it allows for a lot of room to write notes on the sheet it is not a very efficient use of space for a proof sheet.

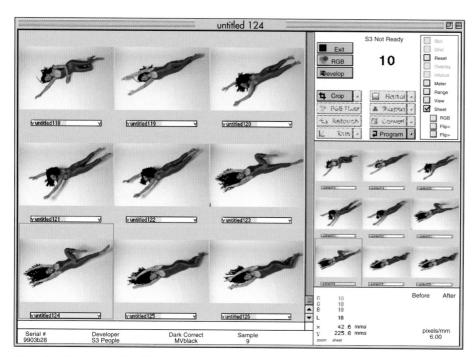

Proof sheet from Megavision S3 camera software

I then re-load images from these sessions into a proof sheet and start deleting bad shots from the proof sheet until I have only "keepers." With the few "keepers" in view, I load additional folders of images into the proof sheet view and repeat the process, deleting bad shots, keeping good shots until I have a super session in the proof sheet view. This can be saved out again into another folder, posted on the Web or printed out as "hard copy" proof sheets. This will drastically cut down on the amount of shots for final review.

Transporting Files

Sometimes you just have to take a lot of shots with you after the shoot and make decisions later. The photographer will batch process the multitude of files and burn a CD of images that you can walk away with. If you have a lot of image files to take back with you, it may take too long to burn to CD or DVD. A better solution is to bring a portable Firewire disk like the ones made by VST. These can hold thirty gigs in a unit the size of a cigarette package and operate without the need for an external power source. This type of hard drive is especially well adapted to location shoots where power supply can be an issue

Taking the files back with you is always preferable to waiting around for printed proof sheets that you look at with a loupe and calling in requests for final files later. The ink jet prints commonly made for proof sheets are not like the "continuous tone" black-and-white proof sheets you are used to—the resolution, under the loupe, is terrible! It is much nicer to look at the image files on screen and be able to zoom into them in Photoshop.

This 30-gig portable self-contained Firewire hard drive is ideal for transporting large amounts of digital image data. All critical image data files need to be backed up at the end of the shoot and moved off site to safeguard the shots in case of various disasters. Simply copying files to a large hard drive is the most convenient, least expensive, and fastest method.

Image Databases

What if you have fifty or sixty shots to look at? Well… opening them up one at a time is just plain crazy and even opening up multiple files at the same time leaves you with window clutter. This is where the image database program comes in. Asset management is very important when you are faced with large numbers of image files to look through. Extensis Portfolio and Canto Cumulus are two recommended programs for building image databases. They come in very handy for our image selection problem. Both programs can rapidly build thumbnail pages from folders of images.

Canto Cumulus catalog window

Extensis Portfolio catalog window

The process is very easy—simply drag your folder of images onto the program's icon and an on-screen proof sheet with file name captions is generated automatically. You can look at several pages worth of proof sheets very fast and if you double click a thumbnail the image will open up in Photoshop. You can also print out proof sheets for your client if necessary. If the photographer has this kind of software, she can build the image database for you and supply you with a free "reader" to view the thumbnails.

PREPARING FOR PRINT

Now comes the really scary part! How can you be sure that the beautiful pictures that you see on screen will look as good when you finally print them? This is where you truly learn the meaning of desktop color. You can stop quaking in your boots—it's not as hard as you think it is. Imaging systems have been around for long enough now that all professional digital cameras will be relatively well behaved and images created with them will be easier to deal with than Photo CD scans. Most likely CMYK files are not going to come out that radically different from what you see on your monitor (as long as you did calibrate your monitor). That being said, there are some things you need to know to get the results you want.

First of all, you need to work with photographers that know what they are doing. Ideally, they should be willing to take at least some responsibility for CMYK conversions and they should be willing to supply some sort of proof. Even a color inkjet proof is better than no proof at all and if the proof matches the photographer's screen, you are halfway home. The rest depends on you and your service bureau. Having some working knowledge of color production will help but you can learn what you need to know and delegate the rest as long as you can keep an overview of the process clear.

You are entering the age of color management—that's the good news. The bad news is—you are entering the age of color management! ColorSync, ICC profiles, working spaces, colorimeters, and spectrophotometers (small instruments designed to measure actual colors from monitors and prints) have raised their ugly heads and basically there's no way you can avoid them. At some point, now or in the near future you are going to be faced with some kind of color catastrophe that is a direct result of the misapplication of color management. It doesn't have to happen that often and you can recover from any disaster if you are just a little careful. It is definitely helpful to know something about how color management in Photoshop works.

Let's begin by setting up your color settings in Photoshop properly.

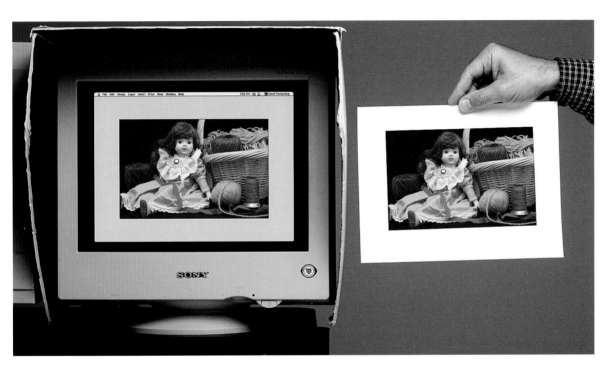

It's possible to get a close match to the screen with your prints but care must be taken to isolate the light falling on the print from the screen. Note the deep homemade hood on this monitor. The print is illuminated with a Solux light fixture (www.solux.net) at about four feet overhead. Moving the print light closer or further away can bring print brightness closer to the screen brightness.

Tech Talk:

PHOTOSHOP
COLOR SETTINGS

It is beyond the scope of this book to provide an in-depth analysis of color management and the interaction between the camera capture software and Adobe Photoshop. What follows are some very basic recommendations for using color management features in Photoshop. Here is a good starting place in the Photoshop Color Settings dialog:

You'll notice that at the top of the dialog there is a drop down menu for default "Settings." Most of the time you can simply pick "U.S. Prepress Defaults" and be OK. Now you can fine-tune this with the following:

Going down from the "Settings" menu skip the "Advanced Mode" check box for now—next we have "Working Spaces." This is where you set your defaults for the color spaces you will be working in most of the time.

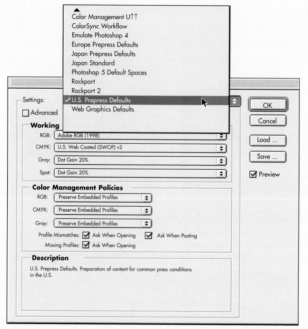

Color settings dialog Defaults

Color Settings dialog Custom

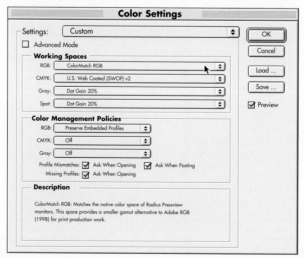

Working Spaces

RGB

Use the setting that your photographer uses; when in doubt, use ColorMatch RGB. There are a lot of arguments over this one setting but basically it doesn't much matter what you choose to use here. I recommend ColorMatch because it is close in character to a well-calibrated monitor and most likely will look close to what you have seen on your photographer's monitor when using the camera software. The only setting for which there seems to be universal agreement is—*don't use sRGB if you are planning to go to print.* Most photographers would have a fit if you use this setting because it would unnecessarily limit the range of colors possible within the image. In practice, again, it most likely will not make a huge difference if your final use is standard offset lithography on a web press (about 90 percent of commercial uses).

CMYK

If you first chose "U.S. Prepress Defaults" in the settings menu this will already be set at "U.S. Web Coated (SWOP) v2"—leave this alone. This will give you decent CMYK conversions from the camera RGB and this is the most logical choice for your default.

Gray

Dot Gain 20 percent is fine and for Spot: Dot Gain 20 percent is OK as well. Now, there are good reasons to have custom dot gain settings here, but they depend on knowing something about your actual press conditions and we don't have time to go into that here. For now let's move onto color management.

Color Management

"Color Management Policies" is the area where you determine the default behavior of Photoshop when opening and saving files that have color profiles associated with them. This is probably the most important part of the settings dialog for you as far as working with digital camera files goes.

RGB

Preserve Embedded Profiles should be selected. You are likely to get RGB camera files with profiles from most photographers shooting digitally. At first you have to assume that these profiles represent good color in the photographed images so you shouldn't discard the profiles without at least checking it out.

CMYK and Gray

Select "off" for "Preserve Embedded Profiles." Now, after the cries of outrage from the color management experts die down, let me explain this choice that clearly departs from the default settings. The main reason for avoiding preserve profiles here has to do with saving CMYK or Grayscale files with profiles attached. First, there doesn't appear to be any particular benefit to using profiles with grayscale documents. All black ink files are not that hard to deal with anyway, and a reasonable proof will tell you more about the file than a profile ever would. CMYK files can benefit from a profile describing its color but, again, here we are more likely to avoid problems if we simply ignore profiles in CMYK files.

Once a file leaves our hands, an untagged (no attached profile) file is less likely to get converted into some other flavor of CMYK than one which has a profile because all service bureaus assume that the file is set up for SWOP*. (More on this in the next chapter.) Also there are often problems with older printing RIPs when they encounter a profile in the header of a TIFF file.

*If your CMYK file is some other flavor of CMYK, like a file that is intended for newspaper, you *should* imbed a profile that "tags" the file with this info. I also name such files with as much description as possible like: MyPhoto_NwsprntCMYK.tif

Special Note:
A profile, as applied in color management, is a description of the actual colors the RGB or CMYK numbers represent in a particular file. In essence, it is a standard way of defining color look-up tables that allow us to convert from one colorspace to another—like the additive colorspace of RGB to the subtractive colorspace of CMYK. You will often see a reference to "ICC profiles"—"ICC" stands for International Color Consortium, an association of manufacturers and trade organizations that have established standards for these software "tags" or profiles.

Missing & Mismatched Profiles

The next group of check boxes in the Color Settings should all be checked: Profile Mismatches—ask when opening and ask when pasting. Missing profiles—ask when opening. These settings will cause the appearance of the following dialog when opening files that do not match your default workspace:

This gives you the option to use the embedded profile if there is one or to assign a profile if there is not. We'll talk about why you might want to use various choices here later. The point is that it is better to have choices, so selecting the "Ask" option is always good. In any case DO NOT check the "Convert document's colors to the working space" button. You can always do that later and it's better to at least check out the way the profiled colors are displayed before you make any unnecessary conversions. The same applies to the Missing Profile dialog:

You can "assign" some other profile to play a "what if" game—just DO NOT check the "and convert document to working space" button. Later on, as you become more familiar with the intricacies of color conversions you can decide to automatically convert files.

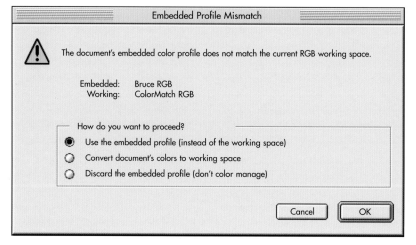

Profile Mismatch dialog

Missing Profile dialog

Settings Descriptions

Finally, as a kind of reassurance, the description area at the bottom of the Color Settings dialog will give you a brief description of what each setting means when you move your cursor over a particular setting. There are reasons for using different settings but for the most part these choices will work best with the workflow you are likely to use with digital camera files.

Alternatives

If your head is starting to hurt, you can relax—there are still options that will allow you to delegate the responsibility for managing the color of the photography. The most obvious is to make the photographer responsible for any and all CMYK conversions. If the photographer hands you CMYK files prepared for your output conditions all you have to do is make sure that you don't inadvertently convert the colors into some other colorspace or profile. Just use the suggested Color Settings in Photoshop, scale, crop, and drop your images into Quark, and you should be in good shape. Get matchprints made of your files to make sure that the color is OK and you're off to the races. Of course, this assumes that the photographer knows what he is doing.

Some photographers may not know what they are doing, especially if they are new to digital. Many are reluctant to get involved with CMYK when they are not going to be in charge of separations or printing (see next chapter "The Politics of Color"). It may also be advantageous to get RGB files if you are going to have multiple uses for the images or if your final output requires RGB. At some point you are probably going to have to deal with converting RGB to CMYK.

Converting RGB Files to CMYK

When the photography looks good in RGB you can simply open up your RGB digital camera files in Photoshop and do Image -> mode-> CMYK. If you have calibrated your monitor and set up your Color Settings in Photoshop to the recommendations, you should have a reasonable CMYK image. If you are into heavy production for a low-end catalog, you probably won't need to do anything else. However, if you are after the best quality reproduction possible, you will need to adjust color and do things like unsharp mask and clean-up retouching before you are done.

If you don't feel you're up to the task of RGB to CMYK conversions plus color corrections, maybe you just don't have the time or the staff to do all that is necessary to get the best possible color, there are still other options. You probably don't want to involve a prepress house in file prep unless you have a special relationship with them because it will be expensive (see next chapter). What do you do if you need to outsource simple file preparation and a suitable freelancer is not available?

An interesting alternative is the service provided by ColorCentric.com. This Internet-based color correction and separation service provides a drag-and-drop application that completely automates the transfer of a JPEG version of your file to their facility. The image is color corrected and a small transform file is returned to you, again, via the Internet. This file is dropped onto their application and your hi-res original is then automatically converted into the finished CMYK file. The fee per image, at the time this book is being written: $15.00US! Sometimes, even if you don't really need this kind of service, you can send a file to ColorCentric.com just to try out an alternative separation. You can then composite the best parts of your version and theirs to get the ultimate color!

ColorCentric.com is an Internet-based color correction and separation service.

Tech Note:

ONLINE COLOR INFO

When you get heavily involved in larger productions it is impractical to spend even a small amount for each image and a 24-hour turnaround can be too long. It will become necessary to control the color process yourself. You will need to become proficient in color correction and conversions as well as the care and handling of ICC profiles. Color profiles can work to great advantage when doing "cross rendering"—that's where you simulate a matchprint with an inkjet print, for instance (an inexpensive way to get a fix on the color before spending money on separations and matchprints). While it is beyond the scope of this book to provide in-depth explanations of ColorSync and the use of ICC profiles, there are numerous online resources available to help. Some of the better ones follow:

ProfileCity.com—a unique service-oriented Web site that offers valuable information, software, and custom profiles. The founding partners, Franz Herbert, Dan Caldwell, Joseph Holmes, and Henry Wilhelm are leaders in color management science and art.

Inkjetmall.com—the Web site started by Jon Cone of Cone Editions Press, a pioneer in fine art Iris inkjet printing. The site has in-depth support for everything relating to inkjet printing, including custom profiles and a unique black-and-white inkjet printing system that supports popular Epson desktop printers.

ProfileCentral.com—another ColorSync oriented site. This Web-enabled database of downloadable profiles is part of CROMIX.com. You can find generic profiles for various press conditions, profiles from different service bureaus, and profiles for popular desktop inkjet printers. They also have tips and suggestions for setting up your system to use profiles.

Colorsync users group—This is an E-mail list for users struggling to understand and implement ColorSync work-flows. There is a fair amount of techy "noise" relating to the intricacies of Lab colorspace standards and printing RIPs but, if you are experiencing any kind of problem relating to ICC profiles, this is where you will find answers. To join the list, go to http://www.lists.apple.com/mailman/listinfo/colorsync-users.

Colortheory list—The signal to noise ratio is a bit higher (in favor of signal) with this list started and moderated by Dan Margulis. You'll find less "techie" and more practical information about color correction and printing issues here. Occasionally the posts degenerate into "ColorSync vs. traditional" philosophical battles until Dan steps in and forces the combatants back on topic. To join this list, go to http://www.ledet.com/margulis. You'll be treated to a page describing Dan's Photoshop training classes (highly recommended) and at the bottom of the page is a link for joining the list.

Digitaldog.net—This is Andrew Rodney's Web site and contains a collection of his articles dealing with ColorSync, digital cameras, and Photoshop—all freely available as PDF files. You'll find detailed step-by-step procedures for setting up Photoshop and using ColorSync.

WORKING WITH PROFILES IN PHOTOSHOP

The most important thing in a ColorSync workflow is a properly calibrated and profiled monitor (see Chapter 2). After that, you can use the ColorSync features in Photoshop to preview your files and control your conversions. The ICC profiles that come with Photoshop are very usable and you may never need to supplement them with anything more exotic. Here are a few general guidelines for working with profiles and digital camera files in Adobe Photoshop 6 or higher. (For a more in-depth examination of Photoshop color management controls look at the book *Real World Photoshop 6* by David Blatner and Bruce Fraser.)

If your photographer has a good profile for the digital camera RGB—great! If not, there's no need to panic. Open the digital camera file in Photoshop. If there is a camera profile embedded then you will most likely get the Profile Mismatch dialog box.

Choose the "Use embedded profile instead of the working space" radio button and look at the file. Sometimes you can get a camera file that has an sRGB profile (sRGB IEC61966-2.1) embedded. In that case choose "Discard the embedded profile (don't color manage)". For some bizarre reason certain semi-professional digital cameras will use sRGB as their default profile. You can safely discard this profile and assign another one. In any case, once the file is opened, look carefully at the color in the image. Most of the time working without an input (camera) profile is better than relying on a mediocre profile.

The document's embedded color profile does not match the current RGB working space.

Embedded: Bruce RGB
Working: ColorMatch RGB

How do you want to proceed?
- ● Use the embedded profile (instead of the working space)
- ○ Convert document's colors to working space
- ○ Discard the embedded profile (don't color manage)

Cancel OK

Profile Mismatch dialog box

Assign Profile menu

It is often worthwhile to play "what if" games with these camera files. Make a duplicate of the image (image-> duplicate). Assign a new profile to this duplicate (image-> mode-> assign profile).

You will get the following dialog.

Assign Profile dialog

Pick "ColorMatch RGB" from the profile menu and compare the result with the original image. You may not see much of a difference or there may be a clear winner. Try out "Adobe 1998 RGB" in the same way. This little exercise can tell you a lot about the color characteristics of the digital camera images you are working with. Some camera files will look pretty good with any of the default RGB workspace profiles—some may be a little more saturated than others but none will be too far off from what you remember the original subject looked like.

The skin tone in this image is an example of what can happen when the wrong profile is used.

Custom Profiles

Other camera files may not look good with anything but a custom profile specific to the camera that produced the file. I have seen this with some Kodak cameras where skin tones were positively lurid in anything but a profile custom made for the camera.

If your camera files are not "tagged" with specific profiles and you're not quite sure what to use, it is probably best to assign ColorMatch RGB. While this is fairly conservative it will usually be close to what you expect the images to look like and it should convert easily into reasonable CMYK color.

Convert to Profile dialog

Using the Convert to Profile Dialog

Rather than simply selecting CMYK under mode, I will almost always convert from RGB to CMYK using the convert-to-profile command (image-> mode-> convert to profile) because it gives me the option of trying out different rendering intents. Let's look at the convert–to-profile dialog:

Leave the "Engine" drop down menu set to Adobe (ACE). Below this you can see the various rendering intent options in the "Intent" drop down. The two that concern us are "Perceptual" and "Relative Colorimetric." Without getting into a really long dissertation on the meaning of these terms, simply note that "Relative Colorimetric" will generate a slightly more saturated result than "Perceptual." If the subject matter of the photo contains a lot of bright saturated colors, you would do well to chose "Perceptual" because the less saturated result will show more tonal "shape" in the saturated areas of the image and will be less likely to posterize or "flatten out." At least 90 percent of the time, saturated colors do not form a large part of the image and you can tolerate a little gamut "clipping" in these areas. "Relative colorimetric" rendering will have brighter color overall so it is most often the best choice. But not always—when it isn't it can really show in the final print.

PERCEPTUAL

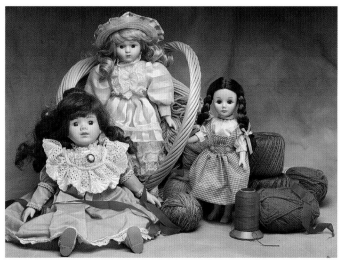

The same RGB file converted using different rendering intents with the same profile. The difference between "Relative Colorimetric" rendering intent on the right vs. "Perceptual" rendering intent on the left is more noticeable with images that have more muted colors that are completely within the gamut of standard CMYK printing. "Relative" renders in-gamut colors with one-to-one accuracy. "Perceptual" rendering assumes that the RGB file represents the maximum RGB gamut and all colors are compressed inward equally to fit the CMYK gamut—including colors that are already in gamut! Notice the difference in color brightness in the doll's hair and dress colors.

RELATIVE COLORIMETRIC

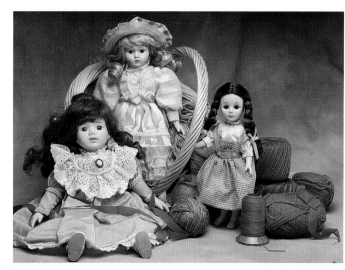

Dolls converted using "Relative Colorimetric" rendering

When in doubt, convert both ways and look at the separate channels in each image—you can often identify problem areas easier this way. It might be advantageous to composite the best parts of each to create the desired result.

Once you have converted an RGB camera file to CMYK you should need to make only some minor adjustments. A ICC profile controlled conversion is no guarantee that the resulting color will be ideal. Color is more of an art than a science and a profile, even a good one, cannot know what your photo should look like—only you can decide that! After the beautifully rich RGB colors of the digital camera file are rendered into the more subdued CMYK colors, you might find that you need to add a little bit of contrast to the subject to give it a bit of "snap." Most of the time you can improve the look of your CMYK files with simple curve adjustments but you have to spend a little bit more time with your files to do that. (A highly recommended book on the subject of color correction in Photoshop is *Professional Photoshop 6* by Dan Margulis.)

The same RGB file converted using different rendering intents with the same profile. Notice the lack of detail in the more cartoon colors of the "Relative Colorimetric" rendering intent on the right vs. the tonal shape in the "perceptual" rendering intent on the left—especially apparent in the red scarf and the green leaves. The fault of "Relative" rendering is that out-of-gamut colors are simply clipped to the nearest in-gamut color resulting in the flattened and posterized look of saturated colors.

RELATIVE COLORIMETRIC

Flowers converted using "Relative Colorimetric" rendering

Soft Proofing

One feature that you might find useful is the soft proofing capability in Photoshop. Under the view menu is the item "Proof Colors."

Proof Colors menu

Select this and by default you will see a screen rendering of your working CMYK setup without actually converting the file. This is what is known as a "soft proof." Usually you will notice that the wonderfully bright RGB colors will become somewhat muted. You can leave your screen in this "soft proof" mode and edit the colors in your RGB file to optimize the CMYK as a kind of pre-separation step. It is important to note, however, that you will not be able to brighten up the colors by pushing saturation in the RGB file. This simply forces more of the colors in the image to be "out of gamut" for CMYK—more colors will fall outside of the reproducible range. You can reduce saturation in certain colors of the RGB file to bring them into gamut and eliminate banding or posterization in the CMYK translation. This can be useful if you see an unusually sharp transition in tone in what should be a smooth area. I tend to use the soft proof more as a quick check before converting rather than spending a lot of time editing RGB colors in this mode.

Proof Setup/Custom menu

Proof Setup dialog

You can create alternative proofing setups by selecting "Custom" in the "Proof Setup" menu.

You will be presented with the "Proof Setup" dialog. Here you can select a profile representing the desired output in the "Profile" menu and a rendering intent in the "Intent" menu. You can also select "Simulate: Paper White or Ink Black" by checking the appropriate check box. Most people have a hard time with the preview as soon as they select either one of these options because the image immediately fades into mud. The problem is that we are not used to seeing this kind of simulation. Photoshop attempts to display the actual color and tone of the printed output factoring the actual brightness of the paper and/or black ink. I have found that if you hide the interface by changing the screen display mode to a black background, it helps by eliminating your white reference on screen.

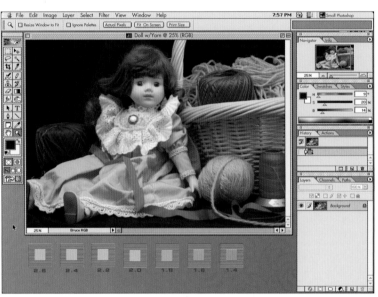

Normal desktop view in Photoshop

Changing the Screen Display Mode

Do this by clicking the right screen display mode button at the bottom of the tool pallet when you select your soft proof. For darker images, the gray desktop (the center button) may prove better. Another thing that helps is to look away from the screen as you select the proof with "Simulate Paper White" or "Ink Black," then look back. It takes some getting used to but you can train yourself to be able to judge the soft proof colors this way. You can also train yourself to judge the soft proof without using the "Simulate Paper White" or "Ink Black" setting and many find this more appropriate for the kind of outputs you do.

Tool Pallet Screen Display Mode

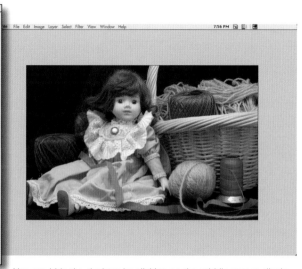

You can hide the desktop by clicking on the middle screen display icon (at the bottom of the tool pallet). Hitting the tab key on the keyboard will hide and show all pallets.

The black background (right icon) also hides the menu bar at the top of the screen.

Printing a Rough Proof

This is something that you should do before you go ahead and order a contract proof or send the file out for separations and a matchprint. Many people are surprised to find that there is a provision for printing simulations inside Photoshop using your desktop printer. While this is not a real substitute for matchprints it can be surprisingly good and at the very least it should help give you a general idea of how the image will look in print. In Photoshop, go to File-> Print Options and check the "Show More Options" check box when the dialog opens.

This is a new printing dialog in Photoshop 6 that makes it more convenient to set up printing parameters. We are most concerned with the color management settings that can be found under the output drop down menu if they are not already visible.

You will notice that we have source space and print space areas. The source space can be the current profile for your document or your proof setup profile. Most of the time, you will be printing from your CMYK version of the camera file so you will check the "Document" radio button—your document profile will be selected here. In some cases, you may want to print from your RGB file and simulate how it will look in your chosen proof setup; chose the "Proof" radio button to get a temporary conversion for the print. The print space is where you select the profile for your desktop printer and the rendering intent for the colorspace conversions. Select your printer profile from the "Profile" drop down menu—fairly straightforward. (Most of the current desktop printers install ColorSync profiles with the printer software and these profiles should be visible in the drop down list.)

The rendering intent ("Intent" drop down) is a little trickier. Most color consultants will recommend that you use "Absolute Colorimetric" for press simulations; the idea here is that "Absolute" guarantees that you get the actual color values of your final output (the press profile that your document uses) on your proof printer. I find that, in practice, it is often better to use "Relative Colorimetric" because "Absolute Colorimetric" attempts to render the color of the paper white in your document profile (which is your press profile). The white point of the paper you use in your desktop printer may not be very close to the expected white point of the paper on press. Usually your desktop printer paper (at least as far as the printer profile is concerned) is brighter than the paper on press. What happens is that the Absolute Colorimetric rendering puts a tone into anything that is white, or close to white, in your print to

simulate the actual white you will get on press. This sounds like a good thing but actually, it can drive you crazy because the image will look muddier than it actually is. The reason is that your visual system (eye + brain) adjusts to the white point of the paper which is clearly visible in the border around the image and anything less white is judged to be, well...not white. So all the highlights in the image look depressed! You can mitigate this effect quite a bit by cutting off the white border. Even when you do this sometimes the image will still seem just a tad too muddy and it can skew your judgment.

Print Options dialog with output menu

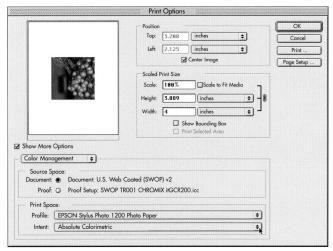

Print Options dialog with Color Management settings

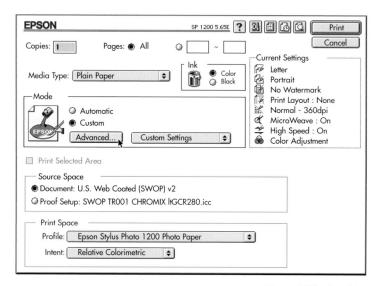

Epson 1200 print dialog

Click on the print button once you have made your color management choices. You will then be presented with the standard print dialog for your chosen printer.

You must set up your printer with no color adjustments! The color conversions necessary for your printer will be handled by the profile you've selected in the print options dialog (usually visible again at the bottom of the print dialog). If you select any kind of printer-managed color here, you run the risk of double transforms that can really whack out your color. To set the Epson driver correctly: in the mode area select the custom radio button and click on the "advanced" button; you will then see the Advanced Options dialog.

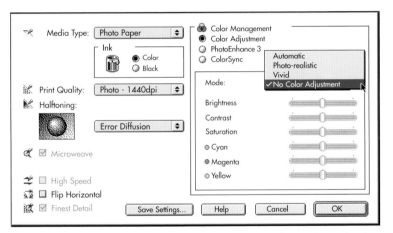

Epson advanced options

Select "Color Adjustment" in the Color Management area and then "No Color Adjustment" in the drop down menu. Choose the media type and print quality that are appropriate for your profile (this should be obvious in the profile name, i.e. "Epson Stylus1200 photo paper," in the case of Epson's supplied profile or, it should be spelled out in the documentation that comes with a third party profile). You might want to save these settings by clicking the "Save Settings" button before exiting this dialog. That way they will be available under the "Custom Settings" menu in the main print dialog.

Take a deep breath and print your proof...

Custom Profiles

The accuracy of the proof print is highly dependent on the quality of your printer profile. The popular Epson inkjet printers now ship with decent profiles but you may still find that a custom profile from a third party vendor (like ProfileCity.com) will give you a result that is closer to the final press. The best profiles are generated by analyzing special targets, supplied by the vendor and printed on your specific printers. Be careful though; sometimes the pursuit of the perfect profile can become like the quest for the Holy Grail, an unending and expensive ordeal. I find that the best pre-visualization depends a great deal on the "wetware" between our ears and it is better to train yourself to make color judgments through experience than to rely completely on color management profiles.

No unsharp mask applied

Unsharp Masking

As a final note, I'd like to briefly cover unsharp masking. This is really the last thing that should be done before turning film and going to print. The reason this is so is because the effect of any sharpening moves depends on the size that a file will be used at in the final output. If you sharpen for a printed size of 3 x 4 inches (8 x 10 cm) and then change your mind and use it at 6 x 8 inches (15 x 20 cm), the result will look over sharpened. Conversely, and more common, if you use the sharpened file smaller than the original intended size, it will seem softer.

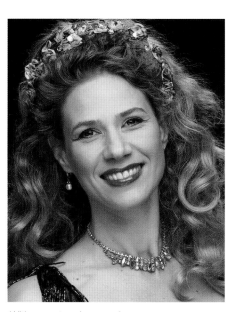

With correct unsharp mask

Too much unsharp mask

I could write a whole chapter on unsharp masking, but suffice it to say here that you must determine the size percentages that you will use the digital camera files at before the images can be scaled and sharpened. Always sharpen using the "unsharp mask" filter (Filter-> Sharpen-> Unsharp Mask) because this gives you much more control over the effect. It takes quite a bit of experience to become expert in the use of this filter and a detailed discussion is beyond the scope of this book. (Dan Margulis' *Professional Photoshop 6* also has an excellent and thorough discussion of unsharp masking.)

All single shot and multi-shot camera files are captured at one size—the pixel dimensions of the CCD. They must be re-sampled up or down to the size that you will use them at 100 percent (at the dpi appropriate for the line screen). Once this is done and only after this is done, you can sharpen the files for final output.

By applying the sharpening effect to luminance only, we can avoid color fringing around edges.

1

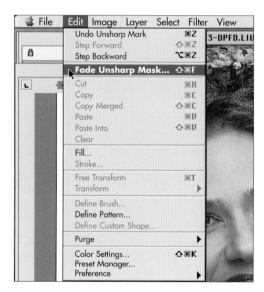

The fade menu allows you to undo various Photoshop events using apply modes. Of particular interest is "Luminosity" which causes the last application of a filter to affect only the luminance in the image.

2

The unsharp mask dialog allows you to preview the effects while you adjust the sliders.

Another little hint: convert the file to LAB first, sharpen the "L" (lightness) channel, and then convert back or simply fade to luminosity after applying the filter in RGB. I've found that you can usually get away with a little more sharpening than you think looks good on screen.

If you don't want to do this chore yourself, you basically have two options. You can make the photographer do it or you can have your prepress worker do it for you. If you have the photographer do the sharpening, you must let her know what size the file needs to be and have her scale the image to the final size, sharpen, and then give you the file. If you don't know sizes after the shoot and you need to play around with the images for awhile first, you may need to have the color house sharpen the files after you scale them to size.

3

COLORSYNC PROFILE WORKFLOW

Calibrate and profile your monitor frequently, especially right before you do any critical color evaluation.

1

Use the embedded profile when opening digital camera files that contain profiles unless the profile is "sRGB"; in that case try assigning one of the standard Photoshop workspace profiles.

2

Convert from your camera RGB to the desired CMYK profile using "Relative Colorimetric" intent to preserve as much color saturation as possible. Use "Perceptual" intent if your subject is composed of mostly saturated colors.

3

Use Photoshop's "Proof Colors" under the view menu to visualize how RGB colors will convert and pull back saturated, out-of-gamut colors before converting.

4

Do not embed profiles in your CMYK or Grayscale output files unless your service bureau requests it or you have prepared the files for unusual output conditions—in either case, make sure that the people you hand off files to know what those profiles are for.

5

Use "Print Options" in Photoshop to select color management options and print desktop "proofs" before sending out for more expensive "contract proofs" or matchprints.

6

05

WHEN BAD COLOR HAPPENS TO GOOD PEOPLE

And now you come to the sad and weepy part of our story. You must get your wonderful, perfectly prepared digital image files to print. In the harsh real world there are often special obstacles set up for images from digital cameras and the designer can literally get caught between a rock and a hard place.

Here's a typical scenario: Your client requests digital photography for any number of reasons and you produce a shoot with no complications. The client approves all the photography from inkjet proofs, the shots look great, and you're off to the prepress house for film and matchprints. You get a call from the prepress house: "These files are not looking right—we're going to have to work on the color to get them to print right".

OK...maybe the SWOP specifications the camera files were prepared to are a little bit different than what the prepress house uses. But then the film comes back with the matchprints and it's all off. It's muddy or light or maybe it has a magenta cast and it's two more turns of film before the job looks right; your client isn't paying for any of it and suddenly it's your worst nightmare. So now you're convinced that digital photography is not there yet—the color just isn't right, blah, blah, blah. Wait a minute....the photographer has done ten different catalog shoots and the color looked great— that's why you chose him in the first place. What gives here?

The Evolution of Digital Workflow

In order to understand what is happening in this example you have to look at the big picture. It's not that the technology of digital-capture is so much to blame, but that the accelerating rush of technology does not leave us with enough time to adapt to change. The fabric of the graphics world is a complex weave of culture, economics, and communication and somehow our little project fits into this mad mix with you having to steer a course through to completion and hopefully reward. You have to deal with a cost-conscious client, the photographer, a color house, and a printer, keep everybody out of each other's way, and get images to look good in print. Look back at the traditional photo workflow and you find established practices with most participants understanding their place in the process. If you change just one small piece of the puzzle, suddenly everything seems to fall apart.

Remember how you saw that with a digital photography workflow the final color is determined earlier, there is no scanning phase in the process, and the role of the prepress house becomes more of simply film output and final proofs? If everything worked perfectly, the inkjet proofs that are generated in the photography studio could be used as the contract proofs for the print job. In fact, with direct-to-plate digital presses you could bypass the prepress house altogether and go straight to the printer. This is ultimately the direction that things are headed—streamline the process, eliminate as many middlemen as possible, and reduce costs and turnaround time. For many people in the industry this is their worst nightmare!

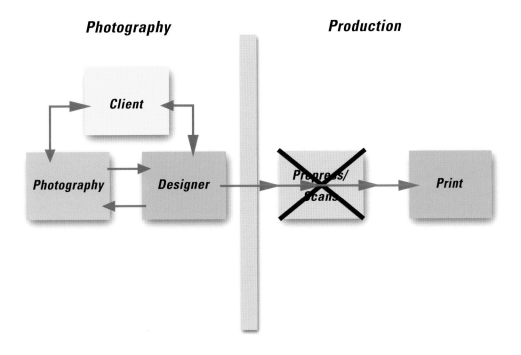

Photography

Production

Client

Photography

Designer

Prepress/ Scans

Print

DTP may not be completely ready to replace traditional separations but that doesn't stop prepress professionals from worrying about reduced income potential. Digital photography is just one more extension of the desktop color revolution/evolution that is squeezing the prepress house from both sides. On one side, designers are doing more of their own file prep and color correction using Photo CDs and even doing their own scanning on inexpensive (and surprisingly good) flatbed scanners. On the other side, printers are investing in digital presses and proofers and in some cases, putting in less expensive, modern film output devices. Now let's throw in the digital photographer who is also providing scans, retouching, and color correction as well as proof prints and you can see how much everything overlaps the prepress house's traditional market. The prepress sales reps are in a panic! They've had to cut prices and give away more services just to hold on to the business they have. What do they have to sell that can't be done somewhere else?

Well, what they have to sell is quality and they HAVE to sell the traditional way of achieving that quality. In fact, they have no incentive to optimize the quality of supplied digital files that compete with their own services. This doesn't have to be a conscious strategy on their part either. Most of the time the prepress worker really believes that his drum scans and the CMYK files generated by his scanner are intrinsically superior to anything created outside his shop. The problem is that he has no experience with anything else.

So now we have an adversarial relationship between digital photographer and prepress worker with the designer in the middle. This is no way to do business! Film-captured images are going to become rare as the demands of commerce increase and the benefits of digital-capture become more widely known. We are all going to have to learn to deal with color in digital files that originate one place and move through different phases of production to end up in various different applications.

With digital photographers providing scans, taking care of their own retouching and color correction, as well as proof prints, the dominant position of the prepress house is changing. This image was originally produced as a consumer ad for the Hotel Nikko in L.A.; all elements were manipulated in Live Picture and Photoshop. Bonsai Tree Lady by Gerald Bybee

COLOR MANAGEMENT

A new graphics discipline has emerged to deal specifically with this one issue. Color management has become a buzzword among imaging professionals who either denounce it vehemently or embrace it with equal abandon. The technology that is being developed to address the problem of color consistency across different capture and display devices is slowly starting to mature and we really can't afford to ignore it. Photoshop, the most widely used graphic software on the planet, has implemented ICC profile-based file conversions and everyone in the industry is going to have to become familiar with it sooner or later.

The funny thing is that people have been doing "color management" for years before that term became associated with ICC profiles and ColorSync. I have worked with master technicians who could work wonders with "impossible" images and make the prints from their Iris inkjet match a press in Hong Kong printing on cheap cardboard packaging material—all without the use of a single ICC profile. Either way, it can be done and we should expect vendors to achieve good color with whatever method they choose. Now, how can we make sure that they do what they are supposed to do?

Color management is a vital part of achieving expected results. The implementation of ICC profile-based file conversions in Photoshop makes color management a hard issue to ignore. This conceptual photo-illustration was produced for Oracle Magazine. Design and Art Direction by Pentagram Design/SF—Kit Hinrichs and Karen Berndt. Talent—Scott Cook—with Mitchell Talent Agency/SF.
Oracle Magazine cover by Gerald Bybee

Things to Watch Out For

Let's go back to our nightmare story. There are perhaps other details that are important but possibly overlooked. Your client requested digital photography but in all previous jobs the work had been handled using a traditional film-based workflow. This is the first warning signal. If there are going to be problems it will invariably happen with the first time you are doing anything. Maybe you've done a number of digital photography jobs before but if this is the first time for your client, pay special attention during the project meetings. Make sure everyone understands the workflow and what they are expected to do.

Another very important detail is that the prepress work will be handled by the shop that's been doing this work for the client for the last three years! Big warning sign! This shop made a fair amount of money doing scans on this project last year—they would like to see that work come back next year! They may seem very cooperative. They know the client's product and how he likes it to print. "Don't worry about anything— we can take care of any color problems," they tell you. Watch your back! If they encounter any problems they are unfamiliar with, they will blame the photography rather than say they "don't know why it turned out that way." They will also show the client every single matchprint from inadequate film because they are not originating the digital files and they are "off the hook" as far as the color goes.

Many separators told me that they factor in the cost of color correction and a certain amount of corrective retouching into the price of the scan. When the scan goes away they have no room in their profit margin for output errors so they are not going to run film twice and only show the client the second turn. Check the edges on the matchprints you've received on other jobs—you might notice something like a "v6" in the file name along the edge of the film.

That may be the only proof you saw (and were charged for) but I guarantee you that they had to run six versions to arrive at that first one because they were having trouble matching the color of the transparency you gave them! They will not turn film twice to get good color on digital camera files.

Edge label from matchprint and separations

It will be a very good idea for you to plan on getting some patch color matchprints from another vendor before you turn over you files for output at this prepress house. Talk to your client about this beforehand. If your client has a long-term relationship with this particular color house, you may not know the full extent of that relationship. Maybe the color house gives the client courtside seats to his favorite team's home games.

He will be inclined to take their side in any dispute. If you show your proof with good color after they show their "bad" proof, the client simply won't believe you and you will have wasted your money on another matchprint. You have to be prepared to "head them off at the pass"—get your proof first, make sure it's good, and show it to your client first.

Using Test Shots and Match Prints

It can also be a good strategy to do a test first, if you have the time. Shoot some product both digitally and with film. HOLD ON TO THE FILM! Run seps on the digital files and get them looking as good as you can (the photographer can usually help quite a bit here because, believe me, they've done this before for themselves). When you have an acceptable matchprint and you've established calibration to the chosen color house, let them scan the film and run seps. You may be surprised to see how many turns of film it takes them to get their scans to look as good as the digital camera files.

Output problems are not necessarily the result of deliberate sabotage on the part of the prepress house. Actually, this is probably quite rare. Most problems stem from various preconceived notions about the nature of digital camera files. I had a prepress vendor ask me why we were shooting digital for a packaging project—their assumption was that digital cameras didn't have enough resolution to go big enough for the package printing. As a consequence, they were looking for rastorization problems and recommending all kinds of retouching "fixes" that were unnecessary. It turned out later that this vendor had an

older digital camera system in-house that they used for low-end catalog work and they assumed that the inferior quality that they got with this system was typical of all digital camera systems. They never considered using their camera for packaging jobs and so they assumed that my digital camera files were not going to work. They went out of their way to convince the client that there would be problems with the digital camera files before they even started working with them. With this attitude it is easy to find fault with all kinds of things in the image and small problems tend to get presented as major issues.

I was asked to do a test of film vs. digital for another job. I love doing this sort of thing because I can always show that, at the very least, digitally-captured images are indistinguishable from film-captured images in the matchprints. Test shots were captured on film and digital, and the matchprints for the digital camera files and scans were compared. This test was supposed to allow me to calibrate to their setup. Instead of being given a chance to calibrate the camera files to their setup they went ahead and "corrected" the camera files themselves. The matchprints were presented to the client before I had a chance to see what their "corrections" looked like. Well, wouldn't you know, their scans looked better—the digital camera files were a little too high contrast and dark! Was this a case of sabotage? Not really. Their experience with digital camera files from someone else suggested that they would need to add contrast and saturation to get the digital camera files to look right. My files actually looked better without any corrections. They were expecting to see flat unsaturated digital files and that's what they saw—so they corrected them! Actually my lower-contrast files made better matchprints than their scanned film. The only thing that saved the job for me was how proudly the sales rep told the client how much work they did to get the digital files to look so good! I told them to run film on the "uncorrected" files, which they gladly did, assuming that the images would look much worse. When the images ended up looking better my client refused to listen to them as they insisted that their 48-bit drum scans would always outperform the CCD images from the digital camera. In the end, he took the job to another vendor who didn't have these prejudices.

LEAVE FILES UNTAGGED

Another prepress prejudice involves ICC profiles. Remember how I recommended that you DO NOT embed ICC profiles in the CMYK files that you send out for film? One of the big reasons is that many color houses and printers have had very bad experiences with ColorSync profiles in the past. Versions of Photoshop previous to 6.0 were seriously flawed in the implementation of ColorSync and almost every user had trouble getting everything to work correctly. Wrong profiles were embedded all the time and colors could be "converted" into and out of a confusing array of RGB and CMYK "workspaces" often with disastrous results. It got to the point where almost every service bureau would tell their clients to turn off all color management features! Current versions of Photoshop have solved the majority of these issues but as far as prepress service bureaus are concerned, "once stung, twice shy." Many times now if a service bureau detects a profile in a file submitted for output, they assume that the color is flawed. These assumptions can impact the way they treat the files and/or the way they charge for file handling. As long as your CMYK is for a "standard" output condition like SWOP you are better off leaving out the profile. When someone opens up an "untagged" file (no profile embedded) in Photoshop they will get the "Missing Profile" dialog asking them what to do—they have to think about it before doing something wrong. "Tagged" files can sometimes get automatically converted to something else depending on the color settings or particular prejudices, so be careful.

Misunderstandings

Sometimes color issues can be the result of something totally unrelated to the digital camera files. I worked on a catalog project that was printing in Hong Kong. We were preparing files here and proofing the images with an Iris inkjet that had been precisely calibrated to match the Hong Kong press. Once the client was convinced that the camera files were looking good in the proofs, we shipped the CMYK files off to Hong Kong where they would do press proofs.

The Chinese liaison (who was the client's employee in Hong Kong) kept complaining about the color of the skin tones in the press proofs. I thought that the issue was with the fact that the press doing the "proofs" was completely different from the press actually running the job (which was the one we calibrated to with the Iris printer). The Hong Kong printer did a lot of color correcting on every shot that had skin tones and charged for this. When the printing came back, everyone complained that the skin tones looked washed out and too yellow! The client was convinced that it was all the fault of the digital camera files, even though the proofs we did looked great! Later, this Chinese liaison (a very nice woman) came over to visit with the head office. We got a chance to visit with her and we showed her our proofs. She said, "See what I mean, all your skin look dead!" The Chinese idea of a good skin tone is what we would consider pale and yellow; they had corrected all the skin tones to look more "Chinese" and she thought she was doing us a favor! To this day this client still thinks that the digital camera files have a problem with skin tones and no amount of evidence will convince her otherwise.

"Floral Essence" © Lee Varis / Varis PhotoMedia

There are a number of other pitfalls related to techniques that color houses and printers use to maximize profits from a particular job. You should be on the look out for the following:

CLIPPING PATHS

Often the color house will tell you they need to put clipping paths into images of products on white backgrounds in order to insure that the background stays white, even if there is zero dot (no tone) in the white of the file that you deliver. If tone is showing up in the white background on the matchprint, you can bet that your "clean" CMYK file went through some kind of inadvertent profile conversion when they opened and re-saved the file. You shouldn't have to pay for a problem that they created. (Make sure that you verify the numbers in the CMYK file by checking with the eyedropper in Photoshop.)

1

ALL-BLACK DROP SHADOWS

The separator will insist that any drop shadows against white be composed of only black ink and they will gladly charge you to fix this. Check out a proof first! All-black drop shadows are not always necessary and sometimes they can be more of a problem than a solution. If you don't see color banding in neutral drop shadows in the proof, it probably isn't worth fixing. All-black drop shadows have a tendency to show a sharp transition at the edge where the tone drops from 1 to 0 percent and this can look worse than any color visible in the shadow.

2

COLOR RETOUCHING

Sometimes color "fixes" will be termed "retouching" and the color house will charge extra because they had to create "alpha channels" or masks. Shifting the "red" out of a black nylon windbreaker should not require time-consuming masking. Make sure that expensive fixes are really necessary. When retouching is needed, the photographer can often provide retouching a lot less expensively than the color house.

3

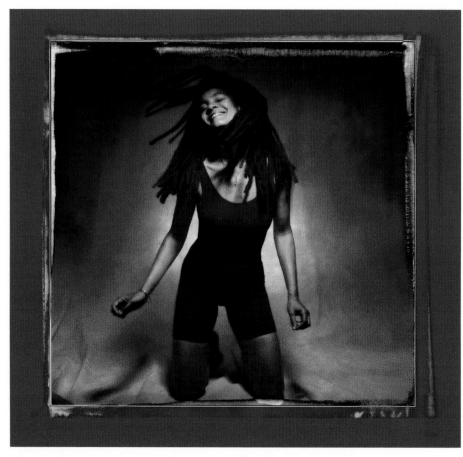

This is a good example of an image where communication about color expectations is imperative.
"Owanda" © Lee Varis / Varis PhotoMedia

COMMUNICATE BEFORE PRINTING

The key to a successful digital photography project is anticipation and communication. If a problem occurs, it won't seem so bad to your client if you have predicted that it might occur even if you can't avoid the problem in the first place. You also need to get the other responsible parties to communicate—that means that the photographer and the separator need to talk before the job is started. All the printing parameters need to be identified up front. You can't tell the photographer that you are going to print at a 133 line screen and then change to a 175 line screen after the files have been prepped for output. Make sure that you know (and everyone else involved knows) who's responsible for each aspect of file preparation. Who is doing retouching? Who is color correcting? Who is doing color conversions? Who is doing the unsharp masking? Sometimes a separator will assume that the photographer doesn't understand prepress so they will not bother with certain information telling him, simply, "we'll take care of it." I have found that photographers with experience doing digital-capture often know more about converting their RGB files to CMYK than the typical prepress worker. Most prepress operations scan film directly to CMYK, relying on the scanner's conversion to render the appropriate CMYK. The scanner files have been calibrated to their film output, often by years of trial and error, and almost nobody that works there knows or remembers what tweaks they may have made to adapt to their older Scitex image setter. These people are the wrong ones to decide how to convert RGB camera files.

Do Your Homework

You need to find out as much as possible about the press conditions from the printer who will print the job. Sheetfed or web-press? Glossy coated or uncoated? What is the total ink limit? What kind of proof process do they like for their press? It is extremely important to know these sorts of things before the photographer (or you) converts the RGB camera files to CMYK. Plan on testing a few representative sample files with the proof process that you will ultimately use on the job before you run separations on a lot of images. "ICC pro-files" for everything do not guarantee that the color will come out right across the board. A small test can supply everyone with enough info to build a correction for the final outputs of this specific job (you might require different tweaks for dark and light images, for instance).

While a good deal of the final color is deter-mined at the photo shoot, the last person to touch the image file is ultimately responsi-ble for the color. Usually that means that the service bureau that outputs the film has a major responsibility to verify that the color

is good. It is your responsibility to make sure they know what you think is good color. Deliver your rough proofs with your files and talk with the separator about your expectations. They will tell you that they won't be able to match the rough proofs exactly—you just want them to know what you consider to look good for these particular images.

Finally, don't let these kinds of problems scare you away from using digital photography. For every vendor that resists the use of digital photography there is another who will be more than happy to work with you to secure your business. Try to use vendors who aren't afraid of color management; they tend to be a little more amenable to working with digital camera files. They may not use a full-blown ICC profile-based workflow but they will be willing to adapt to certain aspects of a color-managed workflow to service your needs. When you find a good service bureau try to steer all your digital-capture projects through them. As you both gain experience with digital photography files, the jobs will run smoother.

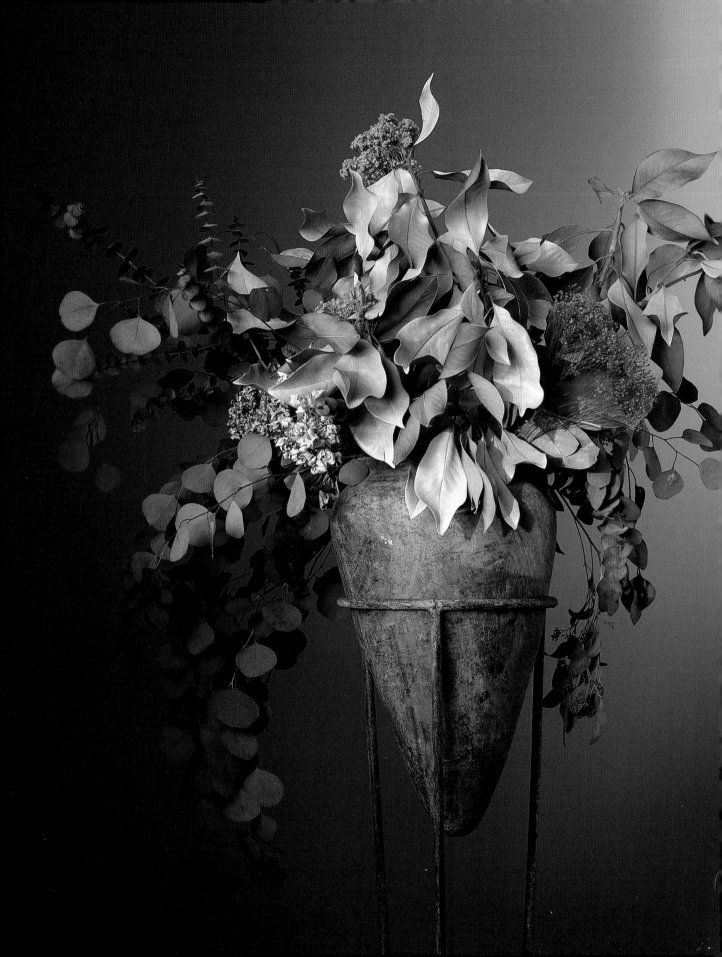

Digital photography is the way of the future. It is being used successfully now for a broad range of applications. The technology is rapidly improving and the cost of ownership for the technology is falling—this means that many more photographers will be using digital-capture. Designers need to understand the benefits of digital-capture and learn how to avoid the pitfalls in order to take advantage of this new image creation tool in their work. The best way to learn is to do! Seek out digital photographers and start using them on small jobs at first. After you get a feel for it you probably won't want to shoot any other way. I'd like to conclude with a few words from Tony Auston of Auston Design Group:

The Auston Design Group is a small, entrepreneurial company with a lot of enthusiasm for designing packaging that works. That is...packaging that catches the consumer's eye, communicates product positioning, creates an appealing image, and sells.

"We specialize in brand development and packaging design for the wine and spirits industry as well as the gourmet food and beverage industries and maintain a list of national and international accounts.

"I first started using digital photography in 1998. As a designer, the thing I like most about digital photography is the ability to instantly see how the image works within our layout. The ability to fine tune the set, change camera angle, adjust depth of field, change lighting and filters all on the fly, and then drop the images into our layouts is a designers dream come true. It is revolutionary to say the least. Polaroid? What's that?

Tony Auston

"Being able to shoot, knowing you can correct flaws in the final images, speeds the shooting process up dramatically. We work with David Bishop of San Francisco on a regular basis. His knowledge of Live Picture and Photoshop are equal to his knowledge of photography and lighting. He is a master at postproduction photo editing. This allows for more creative photo sessions in that we don't get bogged down with the fussy, minute details within the set."

This is one of forty shots documenting the progress of the setting sunlight filtering through a window in David's San Francisco studio. The subtle colors were rendered beautifully on David's PhaseOne LightPhase camera. © David Bishop

"The only drawback I have experienced is the RGB to CMYK conversion. Whose responsibility is it? Photographer? Design-er? Prepress? As a designer that is not an area I want to be held account-able for. I've worked with one photogra-pher who is really digitally savvy. He does his own conversions and color cor-rections, then provides Match Proofs the same as a color separator would. We involve our color separator with all of our final images to ensure quality. Any final adjustments are usually made through them.

Yes, there are photographic elements in this "illu-tration." The fluid nature of digital capture lend itself to this sort of highly manipulated graphic cor position. Image manipulation done in Live Picture "E Speed"© David Bishop

"We once used a Turbo Filter for a shoot. The models were in motion. We had three light sources and varying levels of diffusion on each of them. This, combined with the motion of the models, made for some very interesting images. The ability to see these images instantly allowed for adjustments on the fly that would have taken days to refine with traditional photography.

"Clients seem to like it for the same reasons we do. Prepress seems to be learning to accept their role in adjusting files sent by photographers, although some photographers have no idea about the science of the medium and this can result in some pretty sloppy files being sent to prepress houses. I would equate that with the early days of Mac-produced mechanical art. Designers were just starting to dabble in digital and so were prepress departments. There were also some less than accurate files being sent out. I don't see printers as having any special issues since they are only as good as the film provided to them.

The most important thing I could tell other designers about digital photography is, make sure your RGB to CMYK conversions are accurate, involve your color separator, and be sure to get matchprints. I have only one more thing to say to other designers about digital photography. While the purist may disagree—once you go digital, you'll find it frustrating and hard to go back to traditional photography!"

Bibliography

The following books are highly recommended:

Professional Photoshop 6
by Dan Margulis,
John Wiley & Sons, 2001

The second Photoshop book you should get is more than just a book about Photoshop. This is the best guide to color correction there is, period. Dan Margulis reveals all the techniques for achieving the best possible reproductions in print. The information on color correction by the numbers is invaluable for anyone involved with the commercial application of photography and is especially pertinent for digital photography that will be used in print. A complete strategy for color manipulation is laid out in detail with "Quick and Dirty" summary sections in each chapter. Topics include: establishing neutrals, highlights and shadows, the use of curves, unsharp mask, channel blending, LAB vs. RGB vs. CMYK, color conversion, dot gain, moiré, and more. This is a book that you will want to re-read numerous times.

Real World Photoshop 6
by David Blatner and Bruce Fraser,
Peachpit Press, 2001

If you buy only one Photoshop book, this should be it. This is the ultimate practical guide to image production using Photoshop. Oriented towards the professional user, this book contains detailed instructions on the use of color management and Photoshop's ICC profile workflow. The emphasis is on getting images to look good in print and not wild creative special effects. The core functionality of Photoshop is examined in detail including color settings and preferences, scanning, color correction, unsharp mask, resolution issues, spot color and duotones, masking, file management, and prepping for output.

The following books cover digital photography specifically:

Essentials of Digital Photography
by Akira Kasai & Russel Sparkman,
New Riders Publishing, 1997

Though this book was published over four years ago it remains one of the most comprehensive technical guides to digital photography available. A wealth of technical details, though perhaps more appropriate for the photographer, is presented in a very clear manner. Some information is a bit dated due to numerous advances in equipment and software but the basic concepts and the general overview of imaging techniques are still valid. The chapter on digital photomontage may be of particular interest to the designer working with digital images.

Real World Digital Photography
by Katrin Eismann and Deke
McClelland, Peachpit Press, 1999

This is a more contemporary book that is geared towards non-photography professionals. It is a practical and fairly basic guide to digital photography covering such topics as choosing a digital camera, building a digital darkroom, image editing techniques, QuickTime VR photography, and printing with desktop inkjets. The material presented here is useful for the designer who might wish to do some limited photography herself and it concentrates on a simple approach to capturing images with consumer and mid-level single shot digital cameras.

Contributors

The following artists contributed to this work:

Jeff Smith
Smith/Walker Design
990 Industry Drive
Seattle, WA 98188

Voice: 206-575-3233
Email: Swdesign@halcyon.com

Kim Simmons
Simmons Photogroup
810 Plum Street
Cincinnati, OH 45202

Voice: 513-241-4127
Email: Ksphoto1@one.net

Gerald Bybee
Bybee Studios
1811 Folsom Street
San Francisco, CA 94103

Voice: 415-863-6346
Email: studio@bybee.com
Web: www.bybee.com

Larry Peters Photography
P. O. Box 587
London, OH 43140

Voice: 740-852-2731

Pekka Potka
Studio Pekka Potka Oy
Vilhonvuorenkatu 11A, FIN-00500
Helsinki, Finland

Voice: +358 9 719 915
Fax: +358 9 701 1829
Email: pekka@potkastudios.fi

David Bishop
Bishop Studios/San Francisco
610 22nd Street #311
San Francisco, CA 94107

Voice: 415-558-9532
Fax: 415-626-7643
Web: www.dbsf.com

Tony Auston
Auston Design Group
101 South Coombs Street
Tannery Row, Studio P
Napa, CA 94559

Voice: 707-226-9010
Fax: 707-226-9010
Email: auston@austondesign.com

The following manufacturers contributed photos for this book:

Megavision
P.O. Box 60158
Santa Barbara, CA 93160

Voice: 805-964-1400
Fax: 805-683-6690
Email: info@mega-vision.com

Phase One, U.S., Inc.
24 Woodbine Ave. Suite 15
Northport, NY 11768

Voice: 1-888-PHASEONE
Fax: 1- 631-757-2217
Email: info@phaseone.com

For Phase One in Denmark;

Phase One A/S
Roskildevej 39
DK-2000 Frederiksberg
Denmark

Voice: +45 36 46 0111
Fax: +45 36 46 0222
Email: ofc@phaseone.dk

**Orbiculight Lighting Systems /
Astron Systems, Inc.**
22647 Old Canal Road
Yorba Linda, CA 92887

Voice: 800-398-3480, 714-283-8820
Fax: 714-283-5070
Email: corp@astronsys.com
Web: www.astronsys.com

Glossary

Banding an image defect where a smooth transition in tone is rendered as a succession of flat steps causing breaks or "bands" in the transition

Bicubic Interpolation a method of averaging the value of two adjacent pixels by placing a pixel in between them to expand the size of an image

Binhexed Archives a compressed file format common for Macintosh computer files transmitted over the Internet

Canto Cumulus a computer program for building image databases

CCD (Charged Couple Device) a type of silicon chip that converts photons of light into an electrical signal; used in scanners and video cameras

Cibachrome a common direct-to-positive photographic printing process with a reputation for good image permanence

CLUT (Color Lookup Table) a table of values, each of which corresponds to a different color that can be displayed on a computer monitor or used in an image

CMOS Chip (Complementary Metal-Oxide Semiconductor) an alternative to the CCD, a type of imaging sensor

CMYK (Cyan, Magenta, Yellow, Black) the subtractive process of colors used in color printing

Color Temperature the relative warmth or coolness of white light measured in degrees Kelvin; daylight is considered to be 5000° k, whereas ordinary incandescent light (light bulbs) measures at 3200° k

Colorspace a specifically defined range of colors often associated with a particular type of output or input; the colors that Ektachrome film renders comprise a colorspace that is different than that of the CMYK inks of a printing press

Continuous Tone any method of reproduction that utilizes a continuous range of discreet colors rather than visually mixing dots of a few colors to simulate a full range of color

Contract Proof a proof print used for final color approval before going to press

Cross Rendering using one reproduction method to simulate another—an inexpensive way to get a fix on the color before spending money on separations and matchprints by simulating the matchprint with a less expensive print

Cross-Process a method of processing film to achieve a special effect, e.g. developing slide film in negative chemistry so that the resulting images exhibit exaggerated colors, contrast, and grain

Digitized the general process of rendering an image as a digital file, e.g. converting into 1's and 0's

Dithered Tone a printing method that achieves the appearance of continuous tone by placing a limited number (usually four to six) of colored dots in close proximity and varying either the size or the density of the colored dots to visually mix different colors

DPI (Dots Per Inch) a measurement of resolution for a printer, a scanner, or an image file; in computers it is the density of illuminated points

Duratrans a common type of backlit photo print material

Dye Couplers the chemical structures in film emulsion that hold colors in the silver halide particles of color film

Embedded Profile a set profile that is built into an image file

Extensis Portfolio a computer program for building image databases

FPO (For Position Only) typically a low-resolution image positioned in a document to be replaced with a higher resolution version prior to printing

Flatbed Scanner a type of scanner where the artwork is laid upon a flat sheet of glass prior to scanning versus being affixed onto a drum

F-stop a unit of measure for lens apertures
Gamma the overall lightness/darkness of a digital image or the visual response of a particular output device to input voltages (e.g. the lightness/darkness of a computer monitor)

Grayscale a description of continuous tone black-and-white images or a strip of standard gray tones, ranging from white to black

Ground Glass the focusing glass at the back of a view camera or in the optical viewfinder of a focusing camera system

Hi-Res (High Resolution) a loose term for image files of 300 dpi or greater that are suitable for high-quality printing

ICC (International Color Consortium) an association of manufacturers and trade organizations that have established standards for color descriptive software tags or profiles

Input the digital file from a digital camera or scanner

Iris Inkjet a particular type of inkjet printer; one of the original high-quality digital printers

LED (Light-Emitting Diode) a semiconductor diode that emits light when a voltage is applied to it and is used in an electronic display

Line Screen a printer's term referring to the number of lines of the screen pattern; the higher the line screen, the higher quality of reproduction
Loose Color Proofing a less accurate first proof meant for general viewing rather than final color approval

Low-Res (Low Resolution) images of 72 dpi or thereabouts that are used primarily for layouts, mechanicals, and dummies; images that are not suitable for high-quality printing

Luminance the intensity of light or value range of an image as opposed to the range of hues or chrominance

LVT a type of LED printer made by Kodak that can produce photographic transparencies or slides

Macro Scanning a feature offered by multimode cameras in which a piezo motor moves the CCD in sub-pixel increments building up a higher-res capture in up to sixteen shots

Glossary

Mask many applications allow a user to define an area of an image that can be covered or protected with a mask or stencil so other portions of the image can be manipulated without affecting the masked area

Matchprint the final printed proof made from the separation of negatives prior to printing where final color corrections can be made

Moiré an undesirable pattern in color printing resulting from incorrect screen angles of overprinting halftones; a repetitive interference pattern caused by overlapping symmetrical grids of dots or lines having a differing pitch or angle

Monitor Calibration a process whereby a computer monitor is precisely tuned to view colors for accurate color proofing

Monitor Gamma the measure of overall lightness/darkness and contrast of a computer monitor

Neutrality a rendering of color that shows no particular color bias

Noise the snow or graininess over the whole picture on a monitor

OPI (Open Prepress Interface) a prepress standard file format since the mid 1980s that automatically replaces low-res placeholder images with hi-res images

Orbiculight Light Table a special fluorescent lighting system that wraps light around objects placed inside a covered light table, similar in appearance to a tanning booth

PDF (Portable Document Format) a file format for the transfer of designs across multiple computer platforms

Piezo Motor a tiny electric motor used to move a "mosaic" area array chip in single pixel increments in order to build up a "clean," non-interpolated full-color file in four shots

Pixilation the effect of visible pixels in a digitally produced image

PPI (Pixels Per Inch) the resolution of a digital image expressed in pixels rather than dots

Print Space the colorspace of a print or printer

Profile a digital color lookup table used in color management to describe the actual colors the RGB or CMYK numbers represent in a particular file; also called a "tag"

Proof Viewing Box a special booth used to view slides, transparencies, and prints with a color accurate light source

Rangefinder a type of optical viewfinder that does not use a ground glass to focus the lens, typically found in less expensive, non-single lens reflex cameras

Rendering Intent a setting in color management software that controls how images are converted from one colorspace to another

Resolution the density of pixel information at a particular image size usually given as pixels per inch (ppi) or dots per inch (dpi)

RGB (Red, Green, Blue) the primary additive colors used in display devices and scanners

RIP (Raster Image Processor) a combination of software and hardware that controls the printing process by calculating the bitmaps of images and instructs the printing device to create the images

Rosette clusters of cyan, magenta, yellow, and black dots in a line screen where the distance between the centers of the dots is fixed; the size of individual dots varies in order to change the overall balance of color of the rosette

Scanning Backs a digital camera back that captures images by moving a row of pixels (on a CCD) across the image similar to the way a flat bed scanner works

Separations the process of separating color originals into the primary printing color components (RGB or CMYK)

Signal-to-Noise Ratios the ratio of noise to signal that causes apparent graininess in a digital image

Signal a CCD sensor captures light and converts it into electrical signals, which are then converted into digital data

Single Shot a digital camera that captures a full-color image on an area array chip in one shot; can be used for people and action shots

Soft Proofing a feature in Adobe Photoshop that allows you to view a screen rendering of your CYMK file without actually converting the file

Source Space the current profile for your document before printing, or your input profile

Spectrophotometers small instruments designed to measure actual colors from monitors and prints

SWOP (Specification for Web Offset Printing) a standard for processing colors

Stochastic Screening a digital process that converts images into very small dots of equal size and variable spacing

Tags see Profile

Three Shot also known as a "three pass" camera, a digital camera that builds up full-color captures in three exposures through red, green, and blue filters

TIFF (Tagged Image File Format) a file format, compatible with most applications, used for digital images, especially photographs and other large bitmaps

Tonal Curves adjustments to the value and color of a digital image through the use of a "curves" control interface

Ultimatte Knockout an image processing software application that creates alpha channel "masks" for use in the creation of composite images

Unsharp Masking an image sharpening process that works by increasing the contrast of edge transitions

Upload the means whereby you transfer a file from one disk onto another, from a hard drive onto the Internet, or from a digital camera/scanner to a computer

Wacom Tablet a digital stylus and tablet system used for retouching and painting in image software applications

White Point A movable reference point that defines the lightest area in an image, causing all other areas to be adjusted accordingly

Index

About the Author

Lee Varis has been a professional photographer for over twenty-five years. He began exploring digital imaging fifteen years ago and incorporated it in his work twelve years ago. He has been active as a photographer and digital imaging artist, working primarily in the entertainment print advertising community. His work has been featured on movie posters, video box packaging, album covers, consumer and trade ads, catalogs, and magazine editorials. He currently resides in Los Angeles where he continues to work in photography, now exclusively digital. He also provides digital-capture services for other photographers as well as consulting services for ad agencies, design firms, and corporate clients. He lectures extensively across the U.S. on digital imaging and he maintains a Web site with stock imagery and technical information about digital imaging techniques. You can contact him at:

Voice: 888-964-0024
Email: varis@varis.com
Web: www.varis.com

© Lee Varis/Varis PhotoMedia